IMAGES
of America

# ALTAMONT

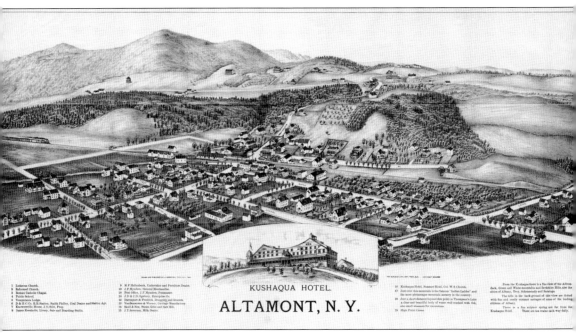

Lucien R. Burleigh (1853–1923) operated the Burleigh Lithographing Company on River Street in Troy, New York. The company produced "bird's-eye" or "panoramic" maps, such as this 1890 map of Altamont. Artists would visit locations, sketch streets and structures, and reproduce the sketches of the area as seen from above. The final sketches were drawn onto large limestone blocks and printed in a process called stone lithography. (Courtesy of the Village of Altamont Archives and Museum.)

ON THE COVER: The Albany County Fair was held in Altamont for the first time in September 1893. In this c. 1903 photograph of the fair, visitors stroll among the carriages and horses, entertained by vendors exhibiting furniture and oil lamps, and there was even a photographer's tent. Among the original fair buildings were, from left to right, rear, the Exhibition Hall, built in 1896; the Ladies Building, built in 1901; and the entrance gate, which consists of two matched structures with a connecting arch, built in 1901. (Courtesy of the Village of Altamont Archives and Museum.)

IMAGES
of America

# ALTAMONT

Keith C. Lee
Foreword by the Honorable John J. McEneny

Copyright © 2014 by Keith C. Lee
ISBN 978-1-4671-2183-5

Published by Arcadia Publishing
Charleston, South Carolina

Printed in the United States of America

Library of Congress Control Number: 2013952569

For all general information, please contact Arcadia Publishing:
Telephone 843-853-2070
Fax 843-853-0044
E-mail sales@arcadiapublishing.com
For customer service and orders:
Toll-Free 1-888-313-2665

Visit us on the Internet at www.arcadiapublishing.com

*This book is dedicated to the memory of those who settled this region; to Arthur B. Gregg (1888–1984), who preserved their story in his research and historical accounts; and to Roger W. Keenholts (1943–1992), whose recognition of the value of preserving artifacts and images forms the basis of the collection of the Village of Altamont Archives and Museum.*

# Contents

Foreword 6

Acknowledgments 7

Introduction 8

1. Beginnings 11

2. Getting Around 47

3. Community 59

4. Government 83

5. A Summer Retreat 95

6. Rest and Recreation 103

7. The Fair 115

About the Organization 127

# Foreword

This book by Keith C. Lee, a longtime advocate for Altamont, is a welcome gift to historians and residents alike. Using narrative and photographs, some familiar and some not seen in modern times, Lee details the development of a rural settlement nestled below the ancient cliffs of the Helderberg Mountains. It is the story of a unique American community that deserves to be told and retold as a vital part of our heritage.

Few people know the full history of Altamont, whose picturesque name was not even used until the late 1880s. The tale begins with Native American hunters and traders, whose forest paths grew into primitive roads that serviced the fields, homes, and small industries of Colonial farmers. After the American Revolution, tenant farmers eventually became landowners. Their Dutch and Palatine German language and customs lingered well into the 19th century, and their descendants still live in the community.

During the Civil War, the Albany & Susquehanna Railroad injected vitality into what would soon become a growing "railroad town." New homes and businesses were located closer to the railroad tracks. Immigrants found opportunity and a new life in the growing economy. The hamlet became the home of the celebrated Altamont Fairgrounds. Wealthy Albanians, now within commuting distance, valued the pastoral atmosphere and built homes and summer retreats in Victorian splendor. In 1890, Altamont officially became a village.

Today, the original high-roofed railroad station serves a new generation as their community library overlooks a park and gazebo surrounded by neighborhoods of historic homes. Old-timers and newcomers share Altamont with pride.

Through the images and stories of long ago, the history and character of the people of Altamont are revealed as they learn, work, worship, and band together to meet the common needs of their community. This book brings to life the memories, struggles, and accomplishments of generations. From pre-Colonial times to the present day, the story of Altamont is the story of people from many backgrounds who have collectively created what is to so many residents and visitors a truly special place in our nation and in our hearts.

—John J. McEneny

# Acknowledgments

Sincere appreciation is expressed to the Honorable John J. McEneny, who wrote the illuminating foreword to this publication.

The work of the volunteers on this project must be especially acknowledged, for we could not have assembled this book without it. The photographic expertise of Ron Ginsburg, the research skills of Connie Rue, and the editing skills of Laura Shore are gratefully acknowledged. In particular, I thank Marijo Dougherty, curator of the archives and museum, for her vision, knowledge, expertise, and leadership throughout.

The collections of the Village of Altamont Archives and Museum exist because of the generous donations over the years from Altamont residents, collectors, and friends. I extend my appreciation and gratitude to all those who had the foresight and generosity of spirit to contribute to the assembly of this important collection, which made this book possible. The historical support of the archives and museum by each succeeding village administration must also be acknowledged. Without their interest in and commitment to preserving our heritage, it would be lost to future generations. Unless otherwise attributed, all images in this book are used courtesy of the Village of Altamont Archives and Museum.

Appreciation is also expressed to those who lent images and stories for the book's contents and to those others who have been quietly supportive along the way to its completion. I would be remiss if I did not also acknowledge the important support to the project of the members of the volunteer organization Altamont Community Tradition (ACT).

A special thank-you goes to our initial editor at Arcadia Publishing, Remy Louis Thurston, who brought us through the early stages of the book's development, and to Rebekah Collinsworth, publisher, who brought us to its completion.

# INTRODUCTION

The village of Altamont, New York, is located about 15 miles southwest of Albany, the capital of New York State. Approximately one square mile in size, Altamont is the only village within the 56 square miles of the town of Guilderland, named for Gelderland, a province in the Netherlands. The village and its immediate surroundings were once part of a tract of land deeded in 1630 by the Dutch West India Company to Killian Van Rensselaer (c. 1586–1643), a wealthy 17th-century diamond and pearl merchant from Amsterdam. The tract encompassed hundreds of square miles on both sides of the Hudson River, both south and west of Albany. Stephen Van Rensselaer II (1742–1769), his nephew, managed the vast expanse of Van Rensselaer's tract, which was operated as a patroonship. Settlers needed the patroon's consent to build and farm, and they were required to pay rent, either in money or goods, for the leased land.

From their settlements along the Hudson River, the early Dutch and German settlers could see the mountains rising in the west. What today are called the Helderbergs were termed Hellebergh, or "bright, clear, mountain," by a small group of Palatine immigrants who, in April 1712, ventured into the wilderness, their destination being the farmlands of the Schoharie Valley. The distant mountains, upon closer view, became the cliffs of a geological formation, later termed the Helderberg Escarpment. These early travelers undoubtedly saw an inspiring view: the shimmer of the rising morning sun on the early spring green of the cliff tops, a view that still inspires today, still "bright and clear." The trail followed by the Palatines is described in Judge John Brown's 1823 pamphlet, *A Brief Sketch of the First Settlement of the County of Schoharie by the Germans*. This leads to the story of this book, on a trail under the Hellebergh, now called Main Street in the village of Altamont.

In the years before the Revolutionary War, ancestors of local families began to settle in the area surrounding what would eventually become Altamont. Frederick Crounse (1714–1777) and his wife, Elizabeth (1716–1796), exhausted from their travels of many months from Germany, settled south of the village sometime after 1754. Their sons Frederick and Philip also developed farms south of the village. Around 1745, Jurrian Severson settled near what is now the intersection of Brandle Road and Main Street in the village. Jacob Van Aernam (1732–1813) also settled on a farm south of the village. The early settlers put aside whatever trades or occupations they may have had in the Old World and became farmers, establishing themselves in the wilderness. Most spoke German or Dutch; few were able to read and write. They cleared the land and hewed out an existence. Most were tenants on the Van Rensselaer lands, termed the West Manor of Rensselaerwyck. There were no formal schools for the children and no doctors. It was a tough existence, but they were independent, yet reliant on friends and their God. The settlers were largely (and contentedly) unfettered by government and separated from territorial disputes. Or so they thought.

During the late 1770s, the war between England and its colonies pitted neighbor against neighbor, and those who cast their lot with the British often lost their land and possessions. After the war,

those who supported the revolution and helped to provision Colonial troops were rewarded with valid titles to their land and no longer were required to pay rent to the patroon. More settlers arrived. Trails became tracks, and tracks became roads. Commercial traffic grew between markets in Albany and Schenectady. Jurrian Severson's grandson George (1766–1813) opened the Wayside Tavern around 1785 at what is today the corner of Helderberg Avenue and Main Street.

It helped that the Wayside Tavern was approximately a day's ride from both Albany and the settlements in the Schoharie Valley, and it became a stagecoach stop.

Around 1800, an Albany merchant, Benjamin Knower, and his brother Timothy bought land and built a hat factory near an inn run by Jacob Aker, east of the current Gun Club Road. Benjamin also built a home, and he was soon followed by others in the area around the Knower place. A schoolhouse for District 7 was built across the road, after the Town of Guilderland commissioners established the town's eight school districts in 1813. On December 24, 1829, the West Guilderland Post Office, the first in the area, opened at the Wayside Tavern, with George Severson (1794–1883), a great-grandson of Jurrian, as postmaster. Dr. Frederick Crounse (1807–1893) opened his practice next to the Knower place, and his father, Jacob, opened the Jacob Crounse Inn, both in 1833. Early maps of the growing settlement show a store, a wagon shop, another inn, and a blacksmith shop. Benjamin Knower died in 1839, and in his honor, his neighbors named the little settlement Knowersville. The following year, the post office was moved from the Wayside Tavern to the Jacob Crounse Inn, and for the next 47 years, the post office name, and the small gathering of homes and businesses along the Olde Schoharie Road, remained Knowersville.

As the country approached mid-century and Southern and Northern politicians grumbled toward civil war, the area around Knowersville continued to develop as a strong farming community. But the farmers between Albany and Schoharie grew tired of muddy, rutted dirt tracks over which they transported their goods. In 1847, a group of entrepreneurs formed the Schoharie and Albany Plank Road Company and built a toll road. Opening in 1849, the road was constructed of rough-hewn planks, providing a stable and relatively dry travel surface. The rumble of wagon wheels on the wood, described as the sound of distant thunder, resounded across the countryside. George Severson's Wayside Tavern, once a thriving business, suffered when the Schoharie Plank Road opened. The traffic that once came by the front door of the tavern was diverted to the new road, and business dwindled. The tavern closed and was converted to residences. Change came quickly, as mud trails became plank roads and, then, with the arrival of a new form of travel and transportation—the railroad.

During the 1850s, the newly formed Albany & Susquehanna (A&S) Railroad Company proposed a new southwesterly route from Albany to Binghamton, including land around Knowersville. On April 19, 1851, A&S Railroad began construction in Albany. By the time the Civil War began in April 1861, development of the new rail route was well under way, and by 1863, the first phase, a 35-mile track from Albany, along the base of the escarpment, and west to the Schoharie Valley, was completed. The first train came through Knowersville on September 16, 1863, jump-starting development and initiating the biggest building boom in the village's history.

In September 1863, the hamlet of Knowersville was centered east of what is now the village of Altamont. The new railway offered regular commercial and passenger service to Albany and a faster means to move products to multiple markets, as well as transportation for building materials and other supplies. While the Civil War raged, Knowersville's core settlement began to shift westward, to the growing commercial area surrounding the first train station, built in spring 1864. The post office moved to the newly built train station. Business opportunities developed to accommodate travelers and to provide needed services to residents. On April 2, 1864, David Becker and Angelica Hilton purchased approximately one acre of land across the street from the train station for $400. Here, Angelica's husband, Silas Hilton, and Benjamin Crounse built a dry goods store, with rooms to let upstairs. The building that Hilton and Crounse constructed is today the oldest continuously used commercial structure in the village, currently housing the Home Front Café, which still serves residents and travelers. In 1867, George Severson built the Severson Hotel. In 1868, Ira Witter built a second dry goods store at the corner of what would

become Main Street and Maple Avenue. In 1871, the cornerstone for the Lutheran Church was laid, and within a year, Knowersville had its first church, serving all denominations. In 1876, James Ogsbury opened a second hotel, the Knowersville House.

The village's population grew. A new, larger schoolhouse was built on School Street (Lincoln Avenue) in 1879. On July 26, 1884, David Crowe published the first edition of the *Knowersville Enterprise*. On April 30, 1886, fire destroyed several businesses and residences on Church Street (Maple Avenue). The size and power of the fire overwhelmed the community's ability to contain it. The Great Fire clarified the obvious: the growing hamlet needed to provide security for its citizens, in the form of a consistent water source and fire protection. To pay for such services, the growing village needed to incorporate and create a political entity with the authority to levy taxes. A committee was constituted to review the laws, survey the land, and do the groundwork for incorporation. On October 18, 1890, by a vote of 102 to 3, Altamont became an incorporated village. A month later, on November 17, voters unanimously elected the village's first administrative officers. Local attorney Hiram Griggs was elected the first president of Altamont.

Prior to incorporation, a group of residents petitioned the postmaster general to change the hamlet's name from Knowersville. Mail for Knowersville was too often misrouted to Knowlesville, in Orleans County, New York, resulting in delays and inconvenience. In July 1887, the name "Peckham" was suggested, after summer resident, New York State Court of Appeals justice Rufus Peckham. In late August 1887, the *Enterprise* reported that, effective October 1, Altamont would be the new name. Altamont, or "high mountain," was derived from High Point, the picnic spot on the Helderberg escarpment overlooking the village. Knower family members stridently protested the change, feeling they were losing their heritage, and on October 29, the *Enterprise* reported that the new name would be "Knower," effective January 1, 1888. But by late November, the *Enterprise* reported that a directive from Washington revoked the change to Knower, affirming the post office name would be Altamont. Local legend states that well-to-do summer resident Lucie Cassidy came up with the name Altamont. What is known is that she liked the name and that she had often entertained the governor of New York, Grover Cleveland, at her summer residence in Knowersville. With Altamont as her choice of name, she telegraphed Cleveland, who had since become the president of the United States, to enlist his support for her choice. He responded, "Altamont it shall be."

Such is the continuing story of the West Manor of Rensselaerwyck, later named West Guilderland, then Knowersville, and today Altamont, the village under the Hellebergh.

# One

# Beginnings

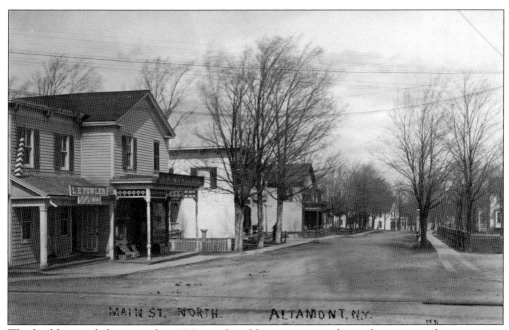

The building at left, erected in 1864, is the oldest continuously used commercial structure in Altamont. In this photograph, it houses L.E. Fowler Ales, Wines & Liquor and the J.F. Mynderse store. Today, the Home Front Café is the occupant. The open door below the Fowler sign was the entrance to Matthew Tice's upstairs barbershop. The barber pole is located on the porch roof, to the left.

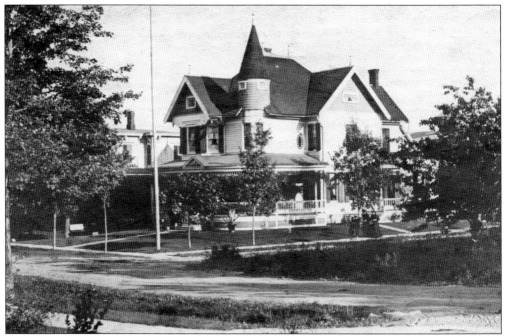

The house at 163 Main Street was built in 1894 for John D. White (1847–1938). White, born in Berne, graduated from Albany Law School in 1882 and moved to Altamont in 1890. He represented Walter S. Church's estate during litigation surrounding Church's purchase of the Van Rensselaer land leases. He also prepared the original organizational papers for the Altamont Fair and for the First National Bank of Altamont.

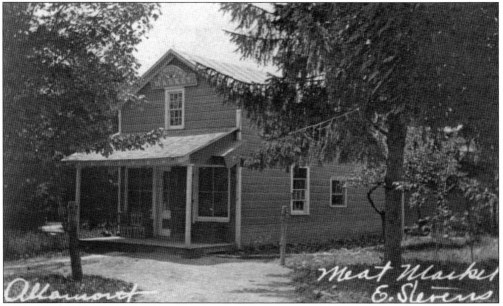

In 1894, Ira Finch, a meat purveyor, purchased a building lot on Lincoln Avenue near the Altamont Reformed Church, constructed a house, and opened an adjacent meat market. In February 1904, after Ira's death, his widow, Vina, rented the market to Enoch Stevens. The original building still stands, part of the current residence located at 105 Jay Street.

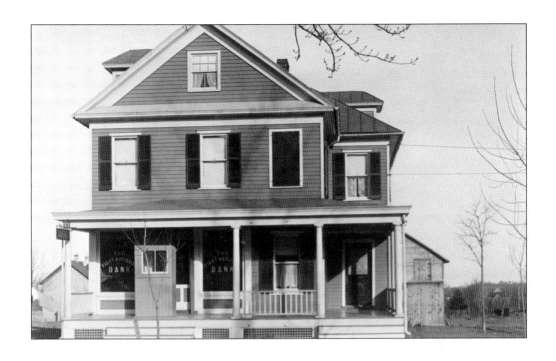

Early in 1910, businessmen Jacob Mynderse, James Keenholts, Newton Ketcham, Edward Crannell, and Millard Hellenbeck petitioned the comptroller of the currency to permit a bank to be opened in Altamont. The First National Bank of Altamont opened its doors on December 5, 1910, after securing capital stock of $25,000 from investors. The bank was located in the Manchester Building (above), at 132 Maple Avenue. Civil War veteran Ketcham was elected the first president of the bank, a position he held until his death in 1925. The bank survived the stock market crash of 1929 and closed briefly after the federally declared bank holiday in March 1933, reopening in December. The bank merged with the National Commercial Bank & Trust of Albany in 1937. The $5 note shown below is part of the Village of Altamont Archives and Museum collection.

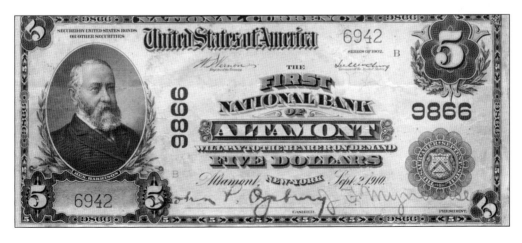

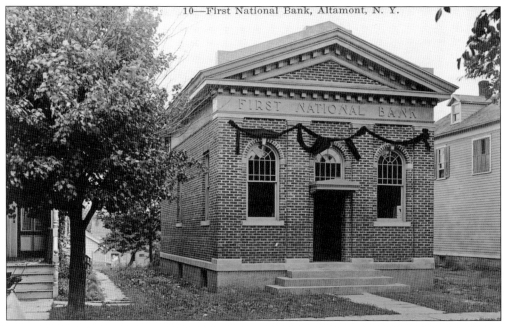

A year after opening, the First National Bank of Altamont purchased land on Park Street from board of directors member James Keenholts. In 1911, the bank opened in a state-of-the-art brick building located approximately on the site of the current Key Bank's parking lot. The brick structure was demolished in 1971. The black bunting drape shown here was hung in memoriam after the death of the bank director, James Keenholts, in 1912.

J. Franklin Mynderse's home was located at the corner of Park and Main Streets. Mynderse (1849–1938) operated a general store in what is today the Home Front Café building. He was a former president of the First National Bank of Altamont. The stately home was located on the site of what is today Angel Park. It was demolished in 1972 to permit the construction of the National Commercial Bank building, now Key Bank.

In 1884, retired farmer Adam Sand and sons Montford and Eugene bought property at what is now 110 Lincoln Avenue from Jacob and Alida Elsass and Daniel and Ellen Philley. The plot was over one acre in size and included a mill. The house shown in the above photograph was built by Eugene Sand around 1892. In 1913, the Sands sold the house and property to William Righter of the Plank & Righter Coal & Feed Company, and it remained in the Righter family until 1946. Sand's Mill (below), operated by Adam Sand and his sons, stood near the current VFW Hall on Mill Street. Adam Sand was killed on February 22, 1890, at age 58, when he was struck while at work in the mill by a burst millstone.

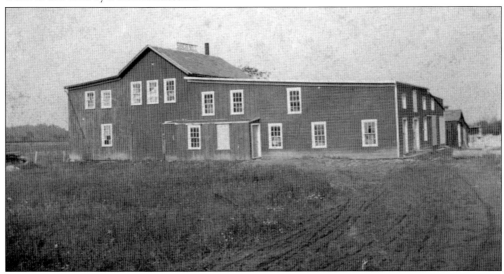

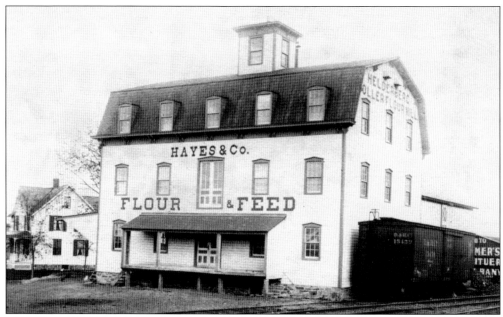

Miles Hayes (1856–1925), a mill operator from Gallupville, New York, was also a founder and vice president of the First National Bank of Altamont. He purchased John H. Ottman's Helderberg Mill property at the end of Park Street after Ottman's death in January 1905. The property included the home seen at left in the above photograph. The mill burned down on December 29, 1928, was rebuilt, and burned again on August 17, 1961. He moved the home that was originally next to the mill onto an adjacent property, and in 1910, he built a large, Classical Revival house (below), which is in the National Register of Historic Places. Hayes died in 1925. After Mrs. Hayes's death in 1959, Mamie Hester inherited the house. In 1970, she sold the house to the Altamont Fair, with the stipulation that it be maintained as a museum.

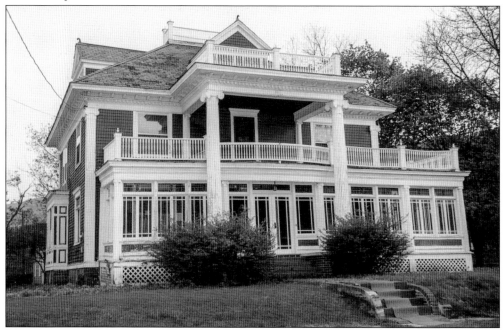

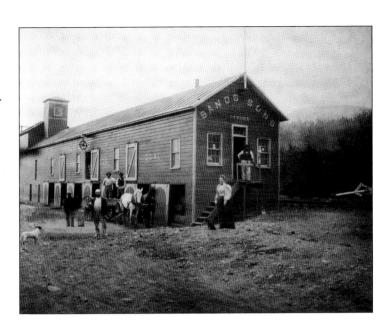

Adam Sand and sons Montford (in front of the wagon) and Eugene were mill operators on what is now Mill Street. The sons continued to operate the business after Adam's death, eventually building a new mill at the end of Park Street around 1893. In 1896, they sold the mill to John H. Ottman. Montford and Eugene then started a coal and feed business in the building shown here, located south of the railroad depot.

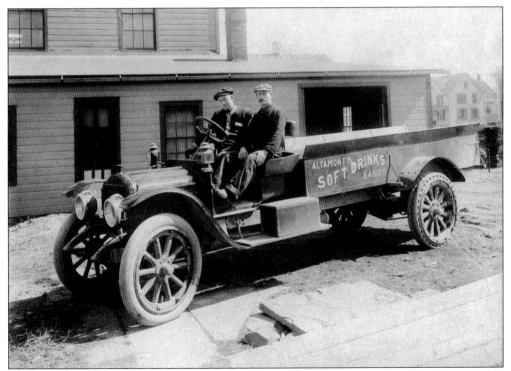

Ivan Sand (left), and his father, Eugene Sand, are pictured in the Sands Bros. soda delivery truck. After their business ventures in mill ownership and in coal and feed merchandising, brothers Eugene and Montford Sand purchased a soda manufacturing business from Alanson Dietz in 1909. They moved the business from Maple Avenue to Park Street and started a bottling and distribution company at the new location.

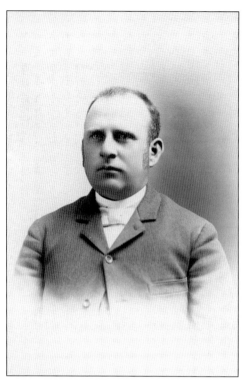

The photograph to the left shows Montford A. Sand (1860–1911), who started the Sands Sons coal and feed business with his younger brother Eugene (1863–1944) in the mid-1890s. They sold the business to the firm of James Keenholts & Co. in 1909. They then bought a soda-bottling business, located at 149 Maple Avenue, from Alanson F. Dietz (1849–1932) and moved it to Park Street as Sand Bros. A well-bundled Montford is pictured below, delivering soft drinks in the company truck. Montford studied music as a youth and was a music teacher as well as an organist and choir leader at St. John's Lutheran Church. He was Altamont president (1902–1903) and was instrumental in the development of the Altamont Illuminating Company. He was fatally injured when he fell and struck his head getting out of his vehicle to assist two ladies whose carriage had overturned. He died on August 22, 1911.

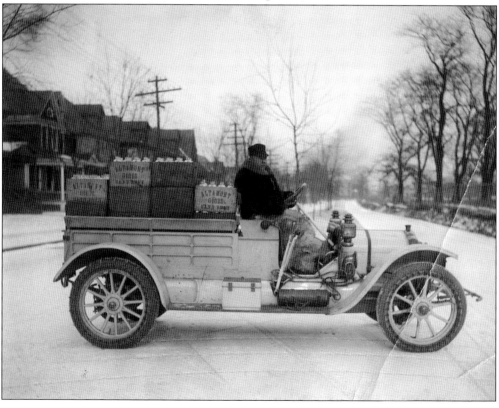

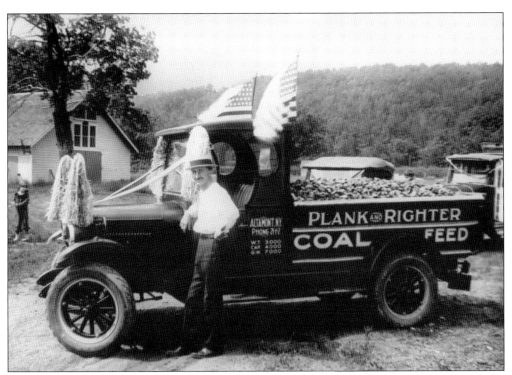

Edwin J. Plank (1868–1953) and his brother-in-law William S. Righter (1869–1945) formed the partnership of Plank & Righter in 1912 and purchased a coal and feed business from James Keenholts. Plank retired from the business in 1932, and Righter (shown here) continued the business with his son until the elder Righter's death in 1945. The firm was purchased by Ward Ackerman on December 1, 1947.

Ward G. Ackerman (1897–1959) was a long-standing businessman in Altamont. After the Hayes Mill burned down in 1928, he bought the property, rebuilt the mill, and began a business that included feed, coal, building materials, and a lumberyard. He purchased the Crannell Lumber business in 1930 and Righter & Son in 1947. His nephew Robert Bushnell took over the business after Ackerman's death in 1959. Ward Ackerman is seen here in the second row at far right.

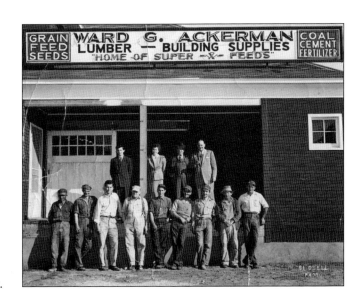

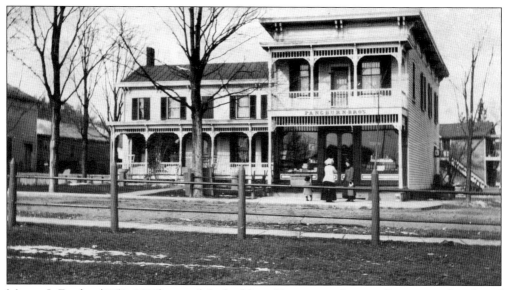

Myron J. Fowler (1852–1907), a prolific builder of homes in the rapidly growing hamlet of Knowersville, built the Pangburn Building (above) for John H. Pangburn in 1886. Pangburn had been in partnership with his father-in-law, J. Franklin Mynderse, but left the partnership to start his own business down the street. The new structure was spacious and ideally located at the corner of Main and Church Streets. The building housed the *Enterprise* newspaper from 1889 to 1893, and it was the post office while Pangburn was postmaster (1885–1889, 1893–1897). The Pangburn family is at left in the photograph below.

The Pangburn Building (left), erected in 1886, anchors the corner of Maple Avenue in this c. 1912 photograph. Across the street is Snyder's Store (far right). The smaller attached addition to Snyder's was later rebuilt as Crabil's Hardware, and the freestanding shed next to it is today's Hungerford Market. Just beyond the shed are the front porches of the Lainhart Building, erected in 1910 and destroyed by fire in 1989.

At age 18, Frank S. Lape married the girl next door and built a two-family home for his parents and his own family on Grand Street around 1886. Pictured here are, from left to right, Frank Lape, Etta Edelman Lape (holding their son Edmund), an unidentified female, and son Frederick on the porch railing.

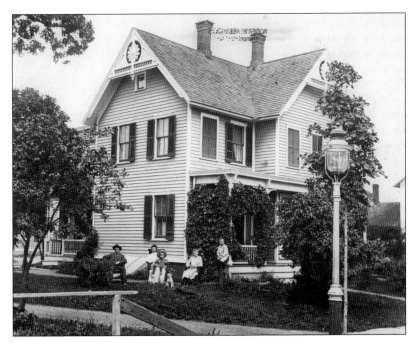

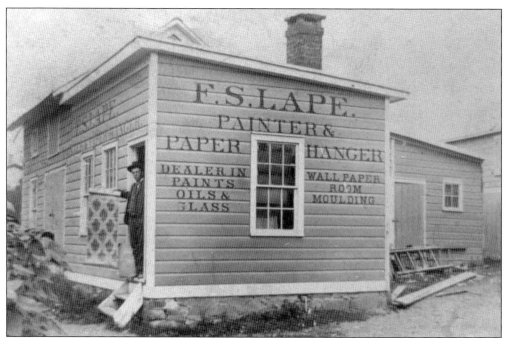

Frank Lape, born in 1869 in East Worcester, New York, came to Knowersville at age 14. After a three-year apprenticeship with cabinetmaker and undertaker John Thierolf, he started a paint and wallpaper business in a converted chicken coop (above) on a lane between what is now Grand and Lark Streets. At age 17, he received a contract to paint and wallpaper Walter Church's massive Kushaqua Hotel resort. In 1905, he purchased a building lot from James Keenholts on Maple Avenue, and by 1906, his Altamont Paint & Paper Store was in business. Frank Lape (at right in the photograph below) was sole operator of the store until his son Edmund became a partner in 1946. Edmund continued to run the store after his father's death in 1952. The store remained in the Lape family until 1983, totaling 97 years of ownership.

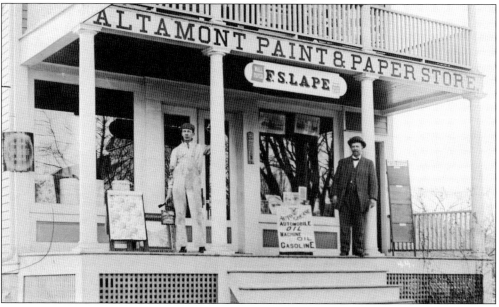

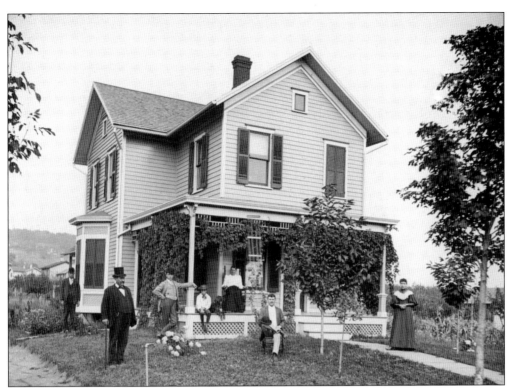

The Philip Edelman family poses at home at 114 Grand Street. At far left is Frank Lape, who owned the home next door, and at far right is his wife, Etta Edelman Lape. Philip Edelman Sr. (1849–1928) is in the top hat, and his sons are, from left to right, William, Frank, and Philip Jr. Mrs. Edelman is on the porch. Edelman Sr. retired in 1912, after a 45-year career in railroading.

Charles V. Beebe, his daughter Edna, and his wife, Amanda Frederick, are pictured in front of their home at 117 Maple Avenue. Charles and Amanda were married on October 22, 1879, in a double wedding, with Amanda's brother Alfred marrying Adah LaGrange, in Guilderland Center, New York. An accomplished harness maker since 1868, Charles owned and operated a harness and saddlery shop next door, at 119 Maple Avenue.

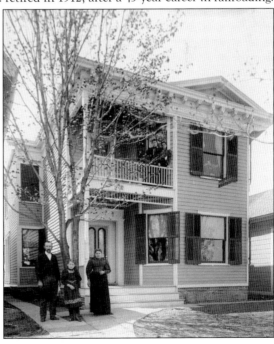

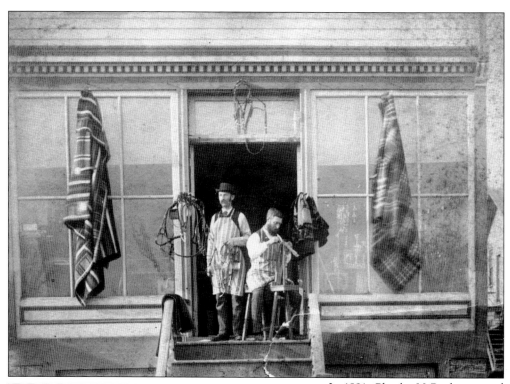

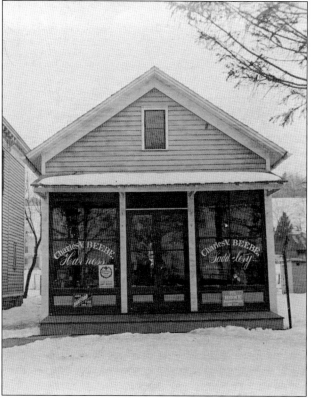

In 1891, Charles V. Beebe opened a harness shop in the Ostrander Building, at what is now 125 Maple Avenue, the *Altamont Enterprise* annex. Above, he is at left with George Hellenbeck in front of the shop. In 1895, Beebe moved his business to 119 Maple Avenue (left), today the site of ReNue Spa. From 1868 to shortly before his death in 1936 at 79, Beebe dedicated himself to his craft, making everything from plow harnesses to fine carriage harnesses for summer resident, US Supreme Court justice Rufus Peckham. He initially made harnesses by hand; as business increased, Beebe added machinery to simplify and speed the work. In addition to operating his business, he was village president (1899–1901), a charter member of the Altamont Hose Company, and treasurer of the local school district for 20 years.

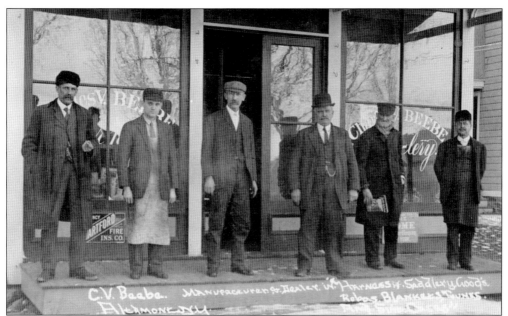

Pictured in front of Charles V. Beebe's harness and saddlery shop at 119 Maple Avenue are, from left to right, Henry Frederick (Beebe's brother-in-law), Minton Becker, Charles Beebe, William Hoag, Melvin Beebe (Charles's uncle), and Frank Cowan (harness shop employee). In addition to harness and saddlery goods, Beebe's shop offered robes, blankets, and insurance for sale. Becker learned the leather trade from Beebe and operated a shoe-repair shop at 125 Maple Avenue.

Irving Lainhart and Ada Beebe (1877–1954) were married on October 15, 1895, and moved into 157 Maple Avenue, their home until shortly before his death in 1964. He operated a grocery and dry goods store in his Lainhart Building for about 15 years. He was born on April 18, 1872, on the Lainhart farm north of the village, and was the first baby baptized in St. John's Lutheran Church.

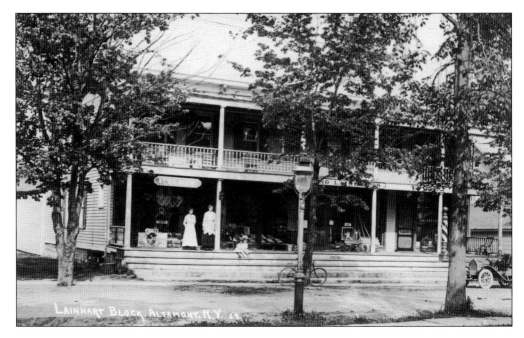

In 1909, Irving Lainhart commissioned Ira and Jacob Weaver to build a store at 112 Maple Avenue. The Irving Lainhart Building, shown above in an early photograph, opened in 1910 with Lainhart's grocery and dry goods store in the center section, a small newsroom on the left, and Joseph Gaglioti's barbershop on the right. In a later photograph (below), the barbershop is now Joe Gaglioti & Son; Martin's Newsroom operated a gasoline pump, visible to the left of the building; and the post office is in the building's center section. The post office moved in 1960, and the Altamont Free Library occupied the space, remaining until 1972. The building was destroyed by fire on March 10, 1989. The site is currently a village-owned parking lot.

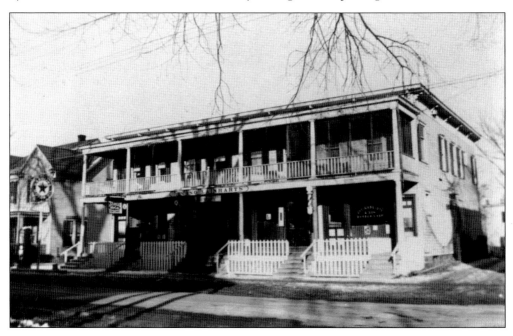

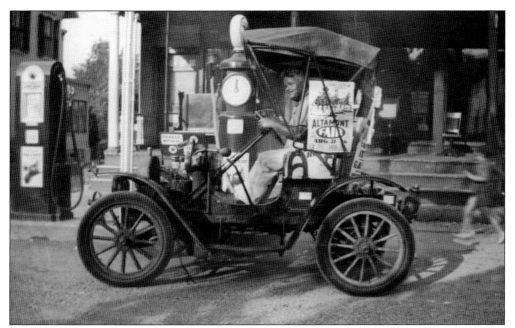

Irving Lainhart was one of the first businessmen in Altamont to use a motorized vehicle as a delivery car. The automobile is a Brush Runabout, built between the years 1907 and 1912. The photograph is undated, but the *Enterprise* of December 20, 1918, reported that Lainhart had purchased a new Ford to take the place of the old Brush delivery car.

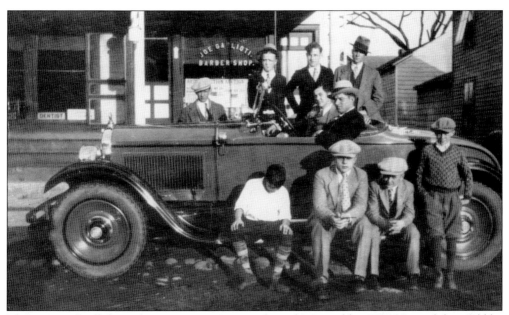

This group of well-dressed young men, posing with a robin's egg blue 1927 Hupmobile, could be straight from central casting for a 1920s movie. They are seen in front of Gaglioti's barbershop in the Lainhart Building, 112 Maple Avenue. Myron "Mike" Kaiser, future husband of Hila Lainhart, is behind the wheel.

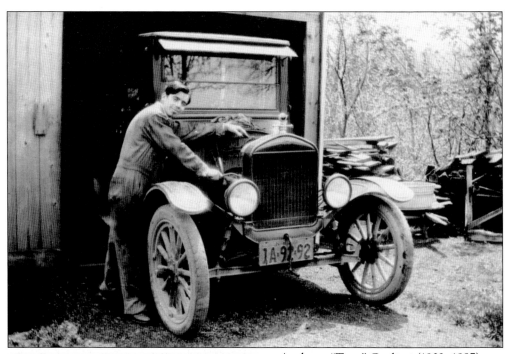

Anthony "Tony" Gaglioti (1903–1997) was born in Italy and came to Altamont at age 10. He cut hair for 77 years, first in his barbershop in the Lainhart Building, and later for individual customers. In this undated photograph, he attends to his Model T automobile. In the 1960s, Gaglioti was a smiling, friendly presence as he did maintenance and cleaning at both the post office and the library.

The S. Wood & Son Bakery, located in a Benjamin Crounse property at the corner of Main Street and Prospect Terrace, was destroyed by fire on Saturday, December 26, 1914. By the following Tuesday, the Woods had purchased the former Masonic hall at 115 Lincoln Avenue (shown here). As soon as a portable oven was secured and installed, they quickly resumed baking at the new location.

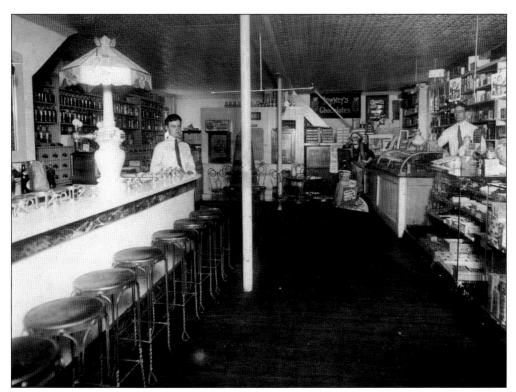

Pharmacist Cyrus Frederick and George W. Davenport opened a pharmacy and general mercantile store on Church Street in 1885. On Friday, April 30, 1886, fire destroyed their business and several others. While the other businesses rebuilt on their previous sites, on May 15, 1886, the *Enterprise* reported that Davenport and Frederick had bought out the firm of Vanderpool, Pangburn & Co. and had opened in the new Pangburn Building at the corner of Main and Church Streets. In 1904, Davenport moved to Albany, and Frederick opened a store on Park Street, operating the business until his 1913 death. John L. Harrington, at right in the above photograph, purchased the business. In 1914, he purchased 182 Main Street and relocated to the new site. Stephan Venear (below) purchased the pharmacy in 1928 and operated it until 1954, selling to pharmacist Gilbert DeLucia, who operated it until 1991.

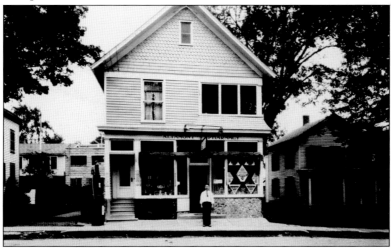

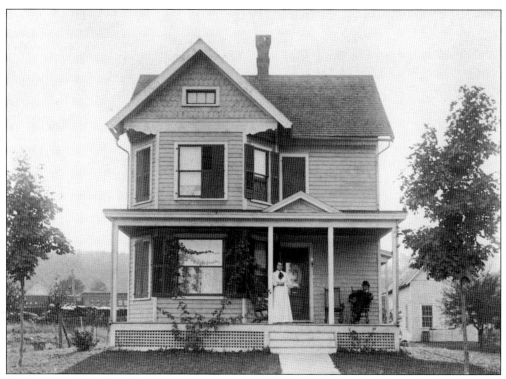

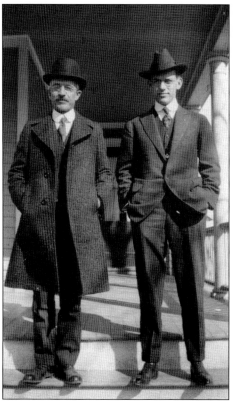

Albert Manchester (1863–1933) moved to Knowersville in 1886 at the age of 23. He partnered first with John Secor in the plumbing and heating business and later with John Pangburn. In the above photograph, taken around 1905, he and his wife are on the porch of their Lark Street home. For the next 40 years, Manchester installed and maintained utility services for the homes and businesses of Altamont. His quality workmanship was rewarded with numerous contracts. In addition, he was the first foreman (chief) of the Altamont Hose Company, serving from 1893 to 1895. He was very active in the formation and support of the Altamont Fair. Pictured at left with his son Jesse, Manchester's last major accomplishment was the construction of a swimming pool and two large reservoirs at Woodlands, the Bernard C. Cobb estate, which was one of Altamont's summer mansions.

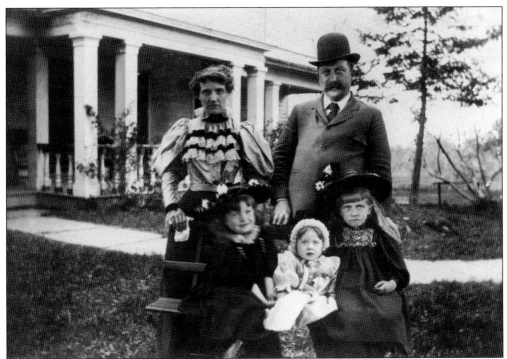

Shown here are Adele Griggs Keenholts and James Keenholts and their daughters, Ella (left), Anita (center), and Helen. They are posing in front of the Crounse Inn, once owned by James Keenholts's father. In a busy career as New York state assemblyman, board of education president, village trustee, real estate entrepreneur, and director of the First National Bank of Altamont, Keenholts had many achievements in his brief life. He died at age 44 on July 4, 1912.

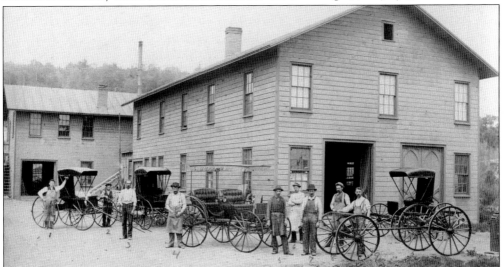

Henry Lockwood built the first carriage factory in Knowersville, on land known as the "Lockwood Estate." The VanBenscoten brothers operated the business until Jacob VanBenscoten and Charles B. Warner formed a partnership around 1880. The April 1886 fire consumed the original building and much of the stock, but VanBenscoten and Warner were able to rebuild their business within a few months, continuing business in a structure still standing today at 127 Maple Avenue.

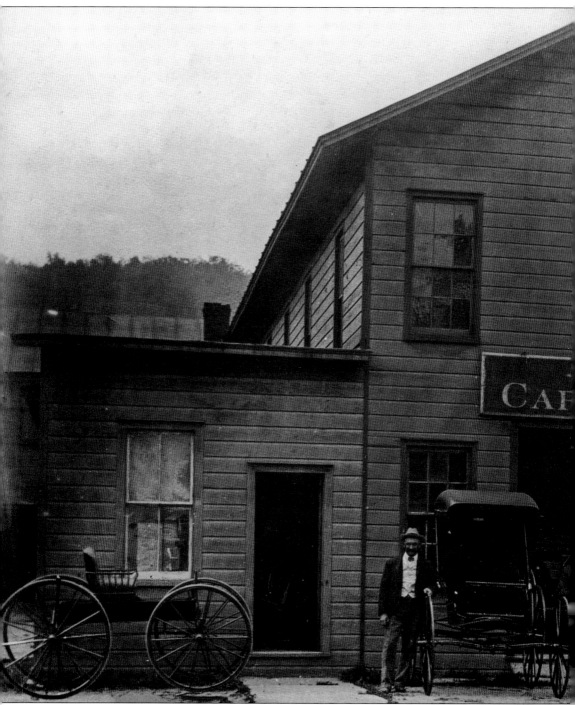

After Jacob VanBenscoten's death in December 1888, the VanBenscoten and Warner partnership was formally dissolved on November 1, 1890. Charles Warner and Almira VanBenscoten, Jacob's widow, formed a partnership and continued the business as C.B. Warner & Co. Almira dissolved the partnership on February 10, 1898, eliminating Warner from the business. Ownership passed to Dayton Whipple (left) and James Keenholts (right) around 1900. James Keenholts was a son

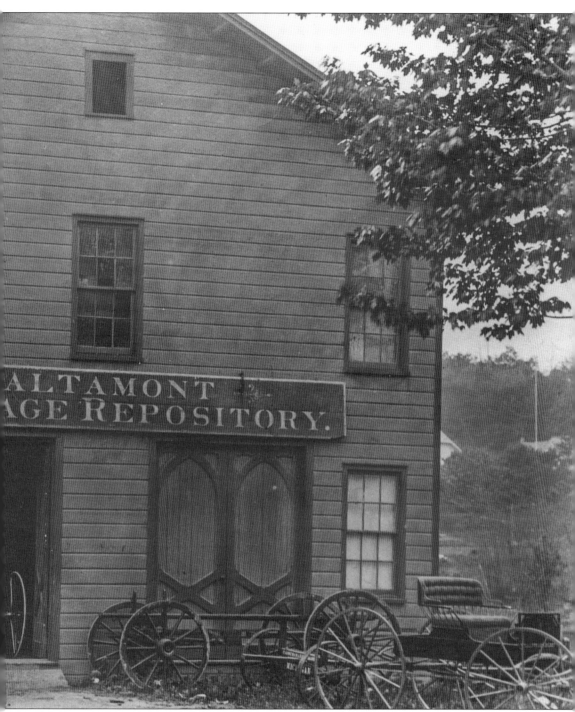

of James Keenholts (1821–1873), past owner of the Jacob Crounse Inn in Old Knowersville. The partnership of Keenholts and Whipple brought the carriage factory into the 20th century, but the increasing popularity and availability of automobiles changed the transportation landscape. Keenholts died in 1912, and Dayton Whipple continued the business until 1916.

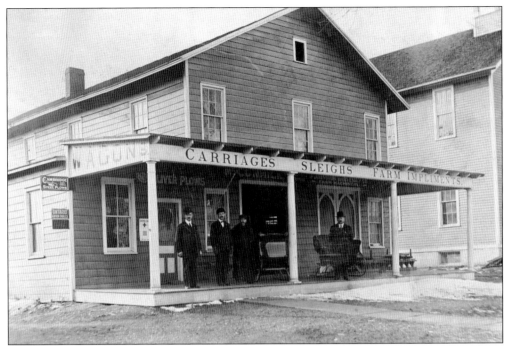

By the middle of the World War I years, the carriage building's appearance had again been modified, and the business was definitely changing. Names like McCormick, Oliver, and Johnson Harvester were common, and farm equipment, such as plows and grain drills, were needed. The art of carriage manufacture became a sideline, and the business dealt primarily with equipment that reflected a broader need. Dayton Whipple sold the building to Morton Makely in 1916.

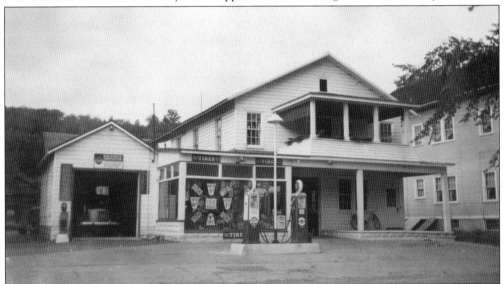

After 43 years, the carriage factory on Maple Avenue was no more. In 1917, Morton Makely overhauled the building into a garage, with living space on the upper floors for his family. An underground gasoline tank was installed in front. The building was Makely's Garage for the next 25 years, and in 1942, Makely converted it into six apartments. It remains today as an apartment building.

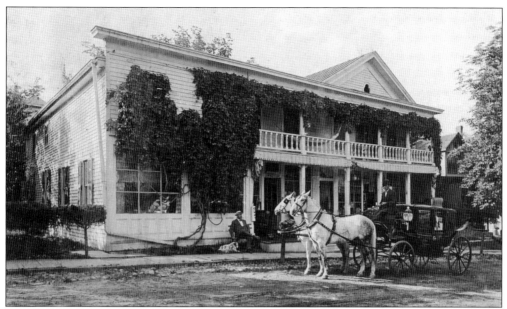

The oldest continuously operated business in Altamont is the Fredendall Funeral Home. In 1877, John Thierolf, 22, arrived in the village as a furniture craftsman, and he soon established a thriving business. At the time, furniture makers were often asked to make coffins, and Thierolf began providing undertaking services for the village. In March 1885, he retired and turned the business over to the partnership of Vanderpool & Ogsbury. The partnership lasted less than a year before dissolution, and Vanderpool then partnered with John H. Pangburn, forming Vanderpool, Pangburn & Co. in February 1886. Thierolf, unhappy with the management of his former business, returned to his building on Helderberg Avenue in February 1886 and resumed business, partnering with Elon Crounse. Thierolf died in September 1886, age 31, and Millard Hellenbeck took over the business in October.

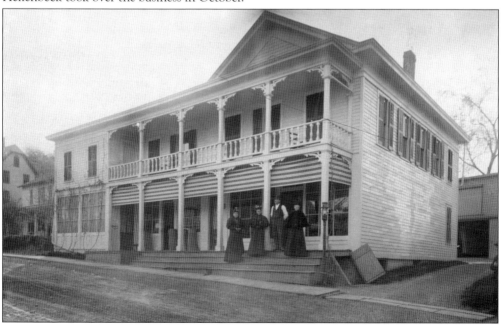

After John Thierolf's 1886 death, Millard F. Hellenbeck (above) continued Thierolf's furniture and undertaking business. Hellenbeck, from Berne, New York, learned his trade of cabinetmaking under his father's direction. He also had undertaking experience, which made him well qualified to take over Thierolf's business. In the photograph below, his furniture wagon, distinctively decorated for a Fourth of July parade, is drawn by his signature matched dappled gray horses. His business did so well, he had a building erected on the fairgrounds for his annual furniture and sales exhibit. In addition to his business expertise, Hellenbeck was a director of the First National Bank of Altamont and a board member of the Albany County Fair Association. He was an avid lover and judge of horses, regularly attending the New York Horse Show at Madison Square Garden.

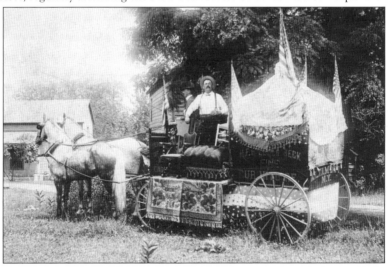

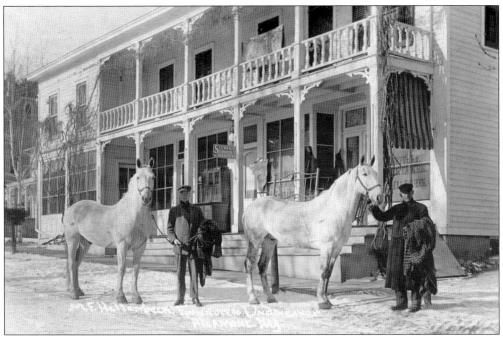

In the above photograph, Harry Fredendall (left) and Steve LaGrange hold the dappled gray horses that for years provided the "pulling power" for M.F. Hellenbeck's furniture wagon and undertaking hearse. They are standing in front of the business on Helderberg Avenue. Fredendall worked for Hellenbeck since age 16 and took over the business after Hellenbeck's death in 1916. He gradually eliminated the furniture merchandising side of the business and developed the undertaking aspect into a full-service funeral home. The practice of conducting funerals from residences and churches was a firmly established custom, but Fredendall, by providing a quiet, dignified space for the bereaved to gather, gradually won over his customers. He built and owned the first motorized hearse (below). Fredendall died in 1949, and the business, still active today, continues to carry his name.

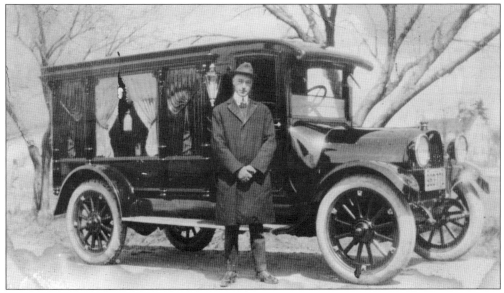

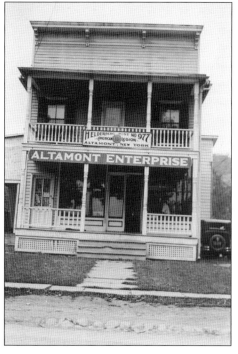

The first edition of the *Knowersville Enterprise* was published on July 16, 1884, by David H. Crowe from his home at the corner of Jay and Church Streets (154 Maple Avenue). Cousins Junius D. and John D. Ogsbury took over the paper in 1886, and for the next 15 years, several commercial structures housed the *Enterprise*, including, using today's designations, the Home Front Café, the Spinning Room, Mio Vino, the Pharmacy building (its last rented location, pictured above), and, finally, 123 Maple Avenue, the current location (at left). The *Enterprise* faithfully recorded weddings, births, and deaths, and it extensively documented the village's growth, as new businesses and homes were built, and as water, sewer, firefighting, and other municipal systems were instituted. The paper became the *Altamont Enterprise* after the village's name changed in 1887, and it continues in print today.

Wheeler Dennison Wright (1851–1933), seen as a young man to the right, designed and built his home at 105 Euclid Avenue (below) in the late 1880s. The only son of Joseph and Emma Gardener Wright, he moved to Knowersville with his parents in 1869. His father ran a dry goods store in the building where the restaurant Mio Vino is located today. Wheeler designed the high school building erected on Grand Street in 1901–1902. In 1915, he offered a design for a large Village Hall building with rooms for village offices, the library, meeting rooms, and space for village-based organizations. Voters, however, did not approve the expense, and the structure was never constructed. He was also a talented cornet player and led the Knowersville Band for several years.

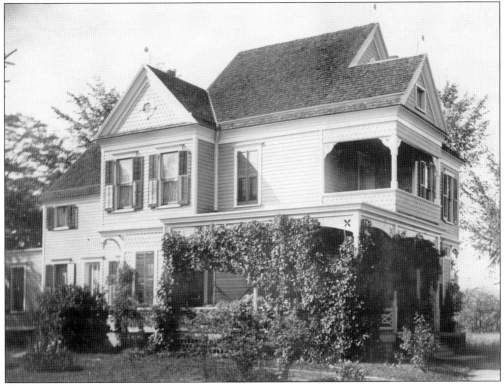

Wheeler D. Wright, apiary farmer, musician, architect, and brother-in-law of Altamont's first president, Hiram Griggs, located his bee farm between what is today Euclid Avenue and Mill Street. His son Leroy is perched in the tree at the far right in this c. 1892 photograph. Wheeler Wright wrote a booklet, *The Honey Bee*, in 1913 for the New York State Department of Agriculture. The booklet can still be found in print.

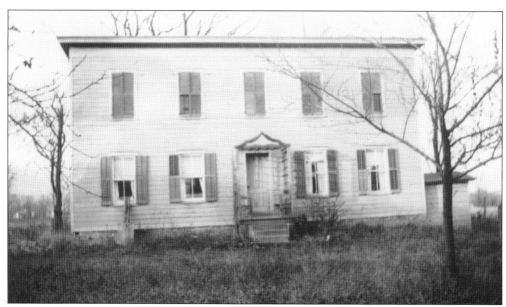

Wheeler Wright built his first home in Knowersville around 1874 on a large plot of land extending between what is now Mill Street and Euclid Avenue. It was here that he started his beekeeping hobby, which became a lifelong avocation. The Altamont Girl Scout troop used the building as a meeting place in 1933. Altamont Post 7062 of the Veterans of Foreign Wars acquired the building in the late 1940s.

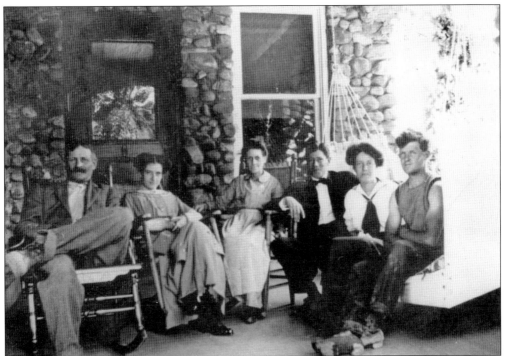

Pictured above are, from left to right, George T. Weaver (1854–1929), daughter Eva, wife, Mary, son Harry, daughter Fanny, and son Albert. George and Mary Reed Weaver emigrated from Canada in 1892, and George found employment as the manager of the Charles Lansing Pruyn estate, one of the summer mansions located above the village. An accomplished stonemason, he built the cobblestone house at 162 Maple Avenue (below) in 1903. His sons Harry (1882–1950) and Albert (1888–1958) were also accomplished masons and builders. George built several homes along Western Avenue and on Schoharie Plank Road. The first Suffrage Club in Altamont was organized in his home in October 1916, with his wife, Mary, as vice president.

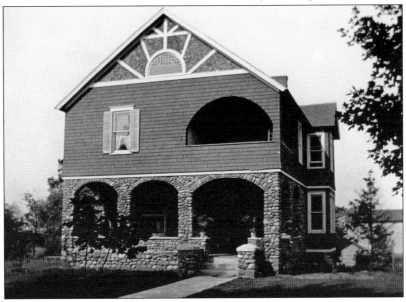

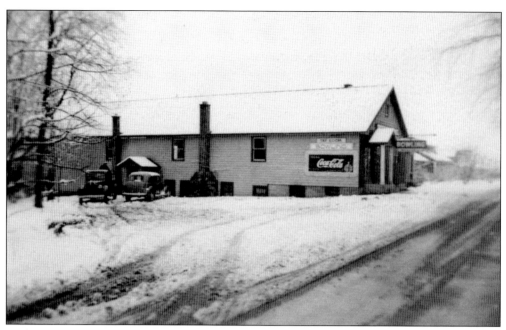

# Bowlers
## OF ALTAMONT AND VICINITY

### I WISH TO ANNOUNCE

That I have entered into a contract with the Brunswick-Balke-Collender Company for the exclusive purchase of FOUR BOWLING ALLEYS and all equipment—which will be installed in a modern, new building on Altamont Boulevard. The building will have space for two additional alleys when patronage warrants their installation.

### Alleys Will Be Ready for Play September 1st, 1933

I solicit in advance the patronage of all bowlers in this community. The building will be equipped for your convenience and comfort.

## RE|ED WEAVER
### ALTAMONT, NEW YORK

Albert Weaver and his son George Reed Weaver (1914–1949) constructed the Weaver Bowling Alleys building at 996 Altamont Boulevard in 1933. As the advertisement to the left indicates, Reed anticipated that the alleys would not be opened until September. The building was completed early, thanks to hard work and cooperation from local businessmen such as Albert J. Manchester (heating and plumbing) and Ward G. Ackerman (lumber, shingles, windows, doors, screens, and other building supplies), as well as assistance from Reed's father, Albert, and his uncle Harry. It opened for business on August 1, 1933, and the bowling alley remained in the family until Reed Weaver's drowning death in 1949. A fire in late October 1934 gutted the building, but the Weavers had the business reopened by Christmas. The building today is the Auto Value Parts Store.

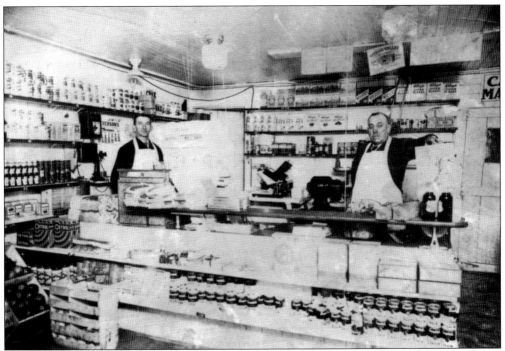

William Williamson (1878–1947) took over the market at 151 Maple Avenue after his brother Ernest's death in 1932. Ernest Williamson had operated the market since he purchased it from George Stevens in 1917. William (right) poses here with Albert Crounse. The building was the location of the first newspaper, the *Golden Era*, printed in 1877 in what was then Knowersville. The building is no longer standing.

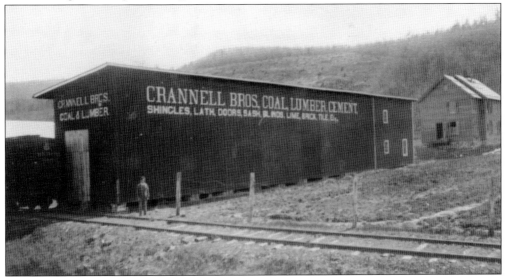

In March 1895, Crannell Bros., a lumber company from Voorheesville, New York, purchased land along the Delaware & Hudson (D&H) Railroad tracks south of the village, with plans to relocate its main lumberyard to Altamont. The business was under the management of Edward G. Crannell (1872–1958). In addition, Crannell was master of Noah Lodge 754, the Fair Association president for 10 years, village president (1904–1905), and bank president for two years.

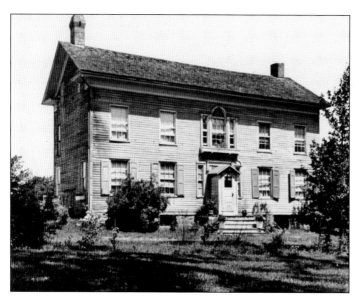

Benjamin Knower built a summer home around 1800 along the Old Schoharie Road in what became Knowersville, named for him after his 1939 death. He was a hatter, businessman, bank president (Merchants & Farmers Bank), and New York State treasurer. The Village of Altamont purchased the Knower House and farm in 1917 and later sold the property to John P. Ogsbury in 1920, reserving a portion for a water-treatment facility.

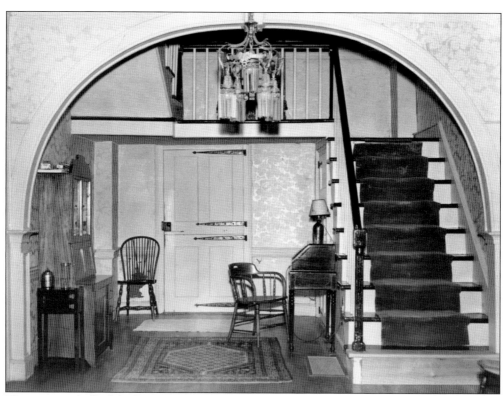

The entrance hall of the Benjamin Knower House was the site of the April 28, 1824, marriage of Benjamin Knower's eldest daughter, Cornelia, to New York State comptroller and future New York governor William L. Marcy. The ceremony took place in the entrance hall alcove. Structurally, the hall today is much the same as it was at the time of the wedding.

Dr. Frederick Crounse's home, built in 1833, still stands at the corner of Gun Club Road and Route 146. Crounse represented the fourth generation of the Crounse family to live in America. For over 60 years, he ministered to his patients and was active in his church and community. A speaker of German, he was an important political figure in the historic Hilltowns tenant farmer rebellion known as the Anti-Rent Wars.

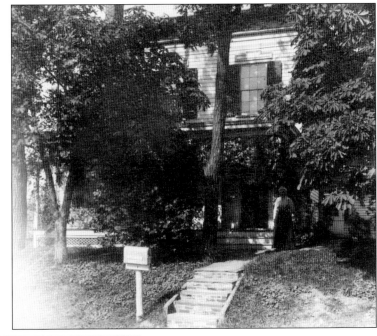

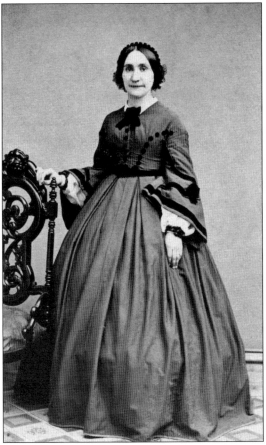

Mary Crounse (1832–1867) was the oldest child of Dr. Frederick Crounse and Elizabeth Keenholts. The Village of Altamont Archive and Museum contains some 60 letters she wrote to her parents and brothers Charles and Eddie while attending Albany Normal School, a New York State teachers college, from 1851 to 1853. The letters provide an intimate window into her thoughts and relationships and an analysis of the times in which she lived. She died in childbirth in 1867.

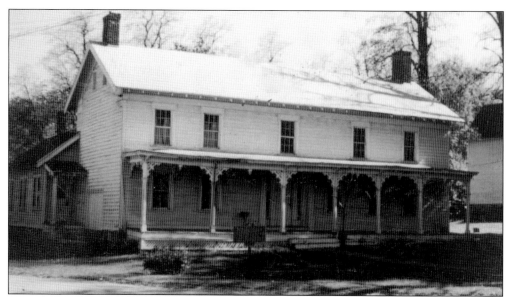

George Severson, a grandson of Jurrian Severson, one of the area's first settlers, built the Wayside Inn around 1785. The inn, site of the area's first post office, closed to travelers after the 1849 opening of the Schoharie Plank Road. It became a private residence, then it succumbed to progress in 1956 when it was demolished and replaced with a gas station. Today, a convenience store is on the site.

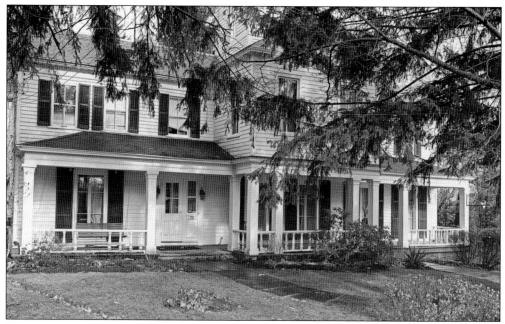

Jacob Crounse (1783–1877) built the inn that carries his name in 1833 near his son Dr. Frederick Crounse, in the small settlement of West Guilderland. Following the death of his neighbor, Benjamin K. Knower (1775–1839), a prominent Albany businessman, the hamlet was renamed Knowersville in his honor. Stagecoaches traveling between Albany and Schoharie would change their horses there, so the inn was a center of activity. It is presently a private home. (Courtesy of Ron Ginsburg.)

# Two
# GETTING AROUND

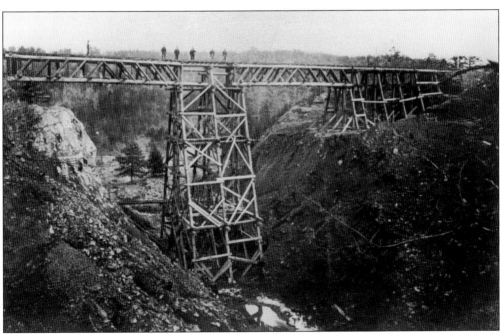

This temporary trestlework was erected along the Albany & Susquehanna Railroad tracks northwest of Knowersville after the rains from the October 4, 1869, freshet inundated much of the Northeast. The area had over 10 inches of rain in two storms within days of each other, and the swollen stream in this gully badly eroded the embankment under the trestle.

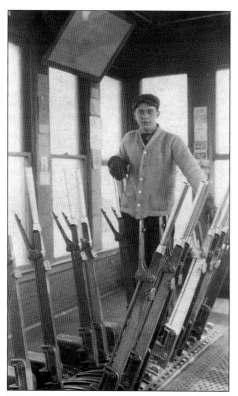

Ellsworth Chesebro (1893–1973) worked at General Electric in Schenectady, New York, before joining the US Navy in November 1916. He returned home from the war to marry Ina Sand, daughter of Eugene Sand, on July 20, 1920, at St. John's Lutheran Church. He was discharged from the Navy on November 7, 1920. He is pictured in the train switching shed at the Altamont Main Street railroad crossing.

Peter Hilton is at the reins of one of his livery vehicles, waiting at the train station. The Commercial Hotel can be seen in the background. Liveries were popular businesses in the growing village, because of the many travelers and day visitors in need of transportation to stores, hotels, or to one of the many fine summer mansions on the hill above the village.

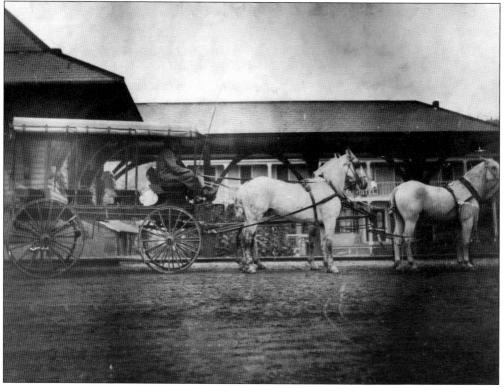

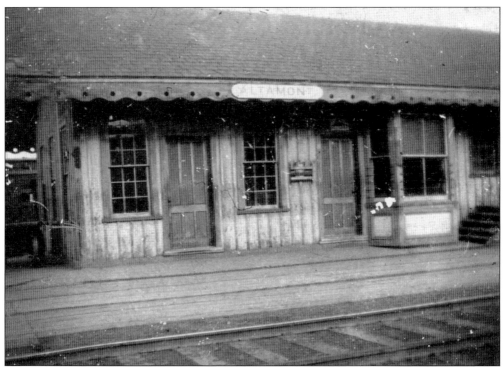

The first train passed through Knowersville on September 16, 1863, and a few months later, in spring 1864, the first train depot was completed. The building, shown above and at left in the photograph below, was utilitarian, serving as both a freight and passenger depot for the growing community. Taking advantage of his proximity to the depot, George Severson, great-grandson of Jurrian Severson, built the Severson House (below, at right) in 1867, on family-owned land across the tracks from the new station. In this way, Severson provided food and lodging to the growing community's many visitors. The 1864 train station was moved south along the tracks in 1896 to make room for the new and improved passenger station, in use today as the home of the Altamont Free Library.

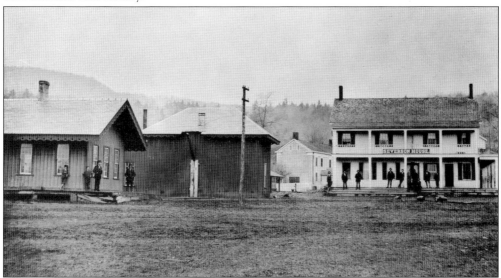

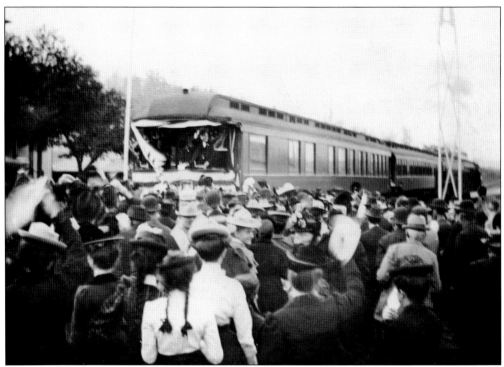

William Jennings Bryan (1860–1925) unsuccessfully ran for president against William McKinley in 1896 and 1900, and he ran again in 1908, losing to William Howard Taft. A dynamic public speaker, Bryan traveled more than 18,000 miles in 27 states during the 1896 campaign. He believed in reaching out to as many people as possible during his campaigns, as he did in this whistle-stop visit to Altamont.

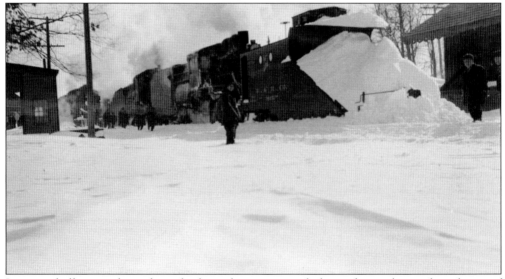

It was a challenge to keep the rails clear of snow, particularly on the tracks north and west of Altamont. This undated photograph was taken in front of the original passenger and freight station, built in 1864. There appears to be two engines behind the plow; the power required to operate the train and push the snow from the tracks was significant.

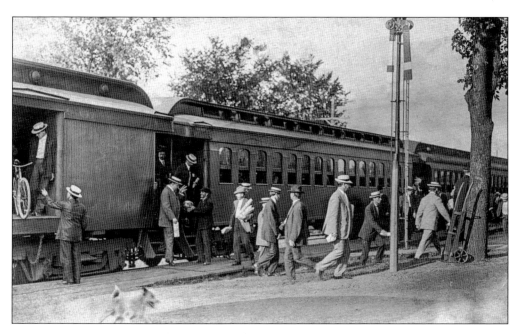

It is clear from the above photograph that no gentleman ever went out without his hat, even at the end of the business day. At left, a passenger waits for his bicycle to be unloaded, while another, left of center, is accosted by a peddler offering what appears to be a watermelon. Below, a train crew poses in front of the model 4-4-0 steam locomotive, often used for short, local runs, hauling freight and passenger cars. Around 1890, there were as many as eight "local" trains that ran between Altamont and Albany, in addition to the through trains. After World War I, the use of automobiles and buses caused a drop in railroad passenger traffic, and in 1929, the Delaware & Hudson line petitioned the Public Service Commission to permit the cancellation of the remaining four local trains, effective May 1, 1930.

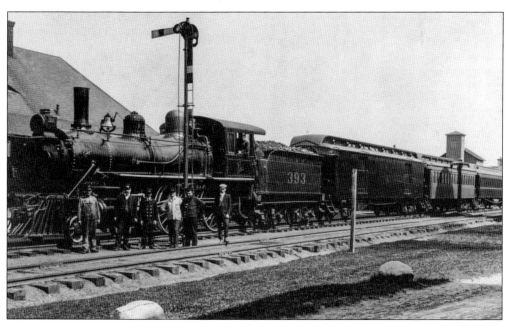

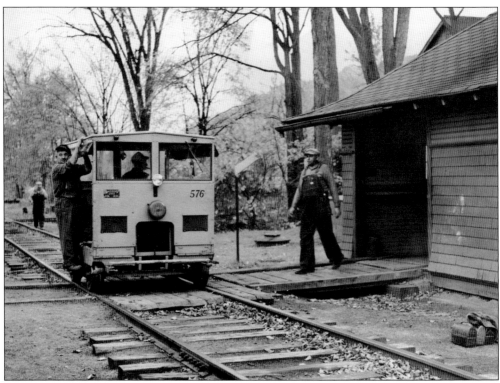

The vehicle shown in these photographs was called a track car, or motor car. It was used to get men and equipment to remote locations on a railway line when track repairs were necessary. In the above photograph, D&H railway worker David Dietz hangs onto the car at left, and foreman Oscar Carlson comes from the storage shed, where the track car would have been stored when not in use. Below, Carlson stands at left, and the rest of his "section gang" is pictured inside the track car. They are, from left to right, John Van Eck, John Martin, Fred ?, ? Dedrick, and David Dietz. Martin worked for the railroad for over 45 years, retiring in 1972. Both Oscar Carlson and his father, Benjamin, were longtime Delaware & Hudson employees.

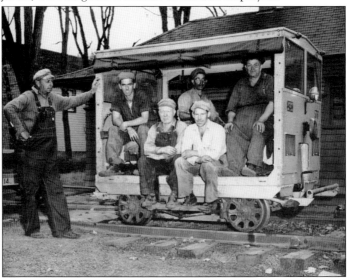

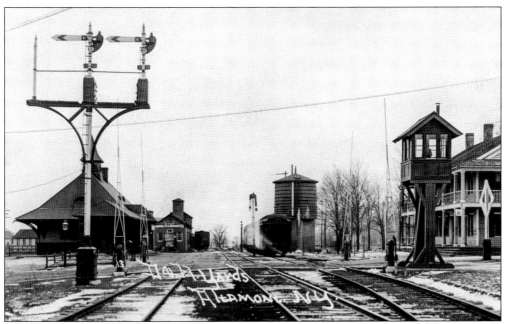

The railroad, whether headed south and then east toward Albany (above), or north and then west toward Binghamton (below), brought Knowersville, later Altamont, the means to grow and develop. Farmland became building lots; wagon trails became streets; and lumber and stone arrived by the trainload. The lure of clean air and cooling breezes brought day travelers and wealthy Albanians, seeking a summer refuge. Before the train, it was a day's ride by horse and carriage from Knowersville to Albany. With the train, the trip became 45 minutes. The first dry goods store, near the center in the photograph below, just beyond the station, could now be restocked daily. The first hotel built after regular train service began is seen to the far right in the above photograph. Food and rest for a day trip, or lodging for an overnight visit, became easily available.

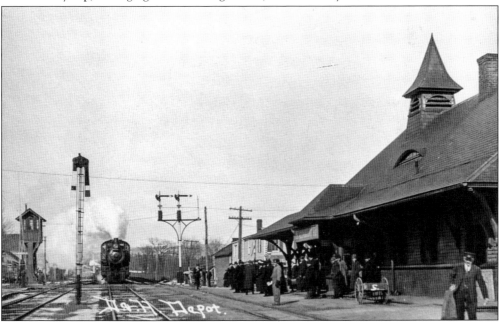

The train depot at Knowersville, built in 1864, quickly became a busy freight office, with merchandise and building materials arriving daily. These original receipts bear the signatures of Henry Hawkins (1817–1891), the first station agent for the new Knowersville station, and Smith Philley (1848–1926), who was named station agent in 1874. Philley became a local businessman, and in 1890, he was elected to the first board of trustees for the newly incorporated Village of Altamont. He was instrumental in the development of the village park (today, Orsini Park). He was promoted to station agent in Glens Falls, New York, and relocated there in 1893. From an 1867 annual report on the state's railroads, the Albany & Susquehanna line moved 57,611 tons of freight and 225,345 passengers. In December 1867, the line extended only to Afton, New York, approximately 116 miles from Albany.

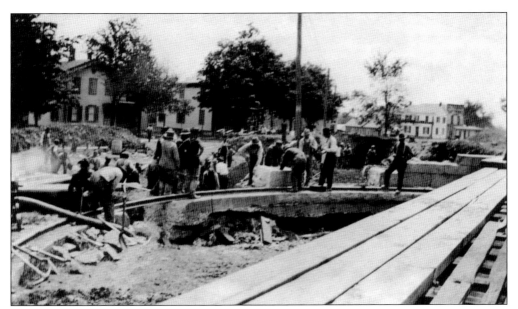

The "local" trains between Albany and Altamont required a turntable to turn the engine around for the run back to Albany. The first turntable was built around 1864, and it was replaced in June 1915 (shown above) with a larger, more efficient one, located near the site of the current post office. The new turntable used hydraulics to make the process of turning the engine much easier. The background view is of Park Street.

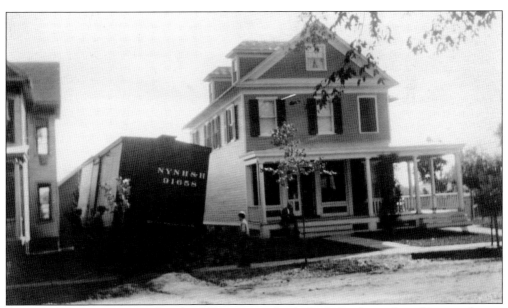

Around 1910, this runaway railcar should have stopped to be loaded at the apple-packing warehouse, located in a portion of the relocated Lincoln Avenue school building at 131 Maple Avenue. Somehow, the railroad car's brakes failed as it came down the railroad spur, and the car continued across Maple Avenue, coming to rest between numbers 132 and 134. No damage occurred to either building.

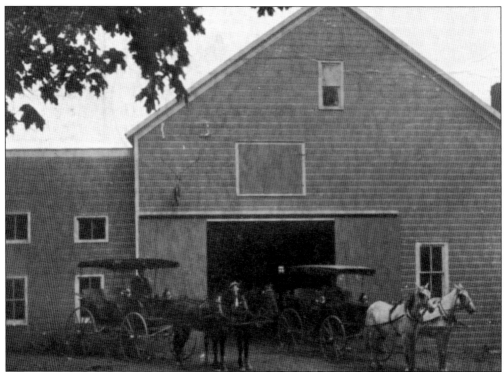

Liveries provided carriages and horses for occasional use, such as a trip into the city or a visit to Aunt Minnie in the next town. Not everyone had the means to own a carriage or a team of horses, or, later, an automobile for such occasional use, so liveries filled a need. Vroman's Livery (above) was located on Prospect Terrace, approximately on the site of today's Altamont Country Values. Past owners of the business, in addition to George Vroman, included Dayton Whipple, James Keenholts, Charles Smith, and Homer Frink. John Becker's Livery (below) was located on Park Street, south of the stream, currently the site of Creekside Apartments. In 1913, in keeping with the times, and to keep his livery up to date, Becker added a five-passenger touring car to his "for-hire" equipment.

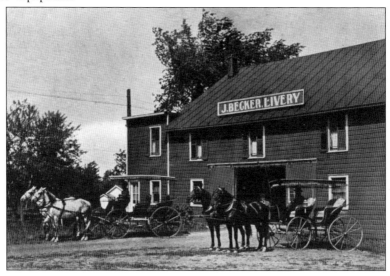

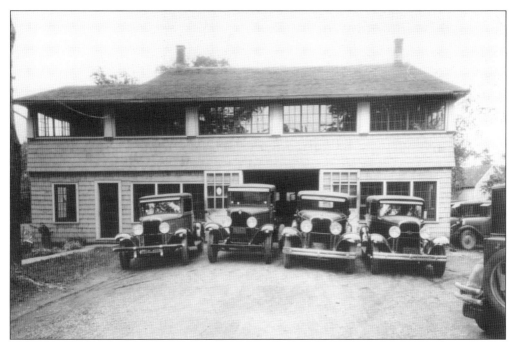

Fred Dorsett (1882–1946) purchased Becker's Livery in 1921, removed the horse stalls, and converted the building to an automobile repair and sales agency (pictured). Dorsett and his wife lived in the flat above the business. He was president of the Albany-Schenectady County Fair Board of Directors until his sudden death in 1946. Westfall Chevrolet took over the business around 1940 and lasted until 1975.

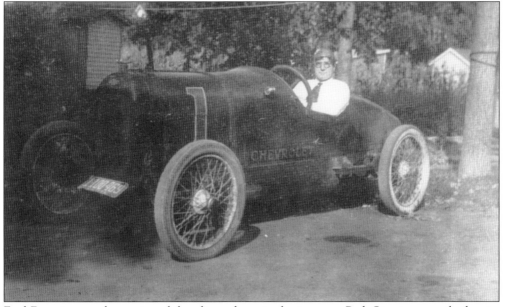

Fred Dorsett owned an automobile sales and service business on Park Street, currently the site of Creekside Apartments. As president of Pyramid Speedways, an organization of Albany and Schenectady County businessmen, as well as president of the Altamont Fair Board, he was in an excellent position to promote automobile racing at the fairgrounds.

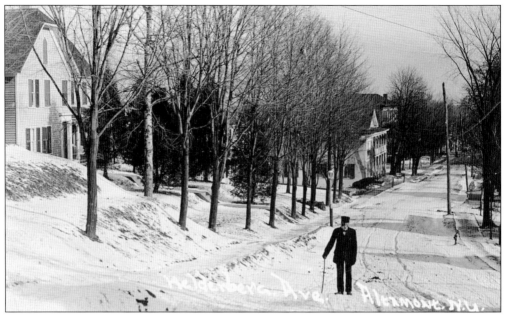

This photograph of Helderberg Avenue in the early 1900s shows the Hellenbeck Furniture store, rear, now Fredendall Funeral Home. First a path, then a trail, and finally a road, Helderberg Avenue was the primary route of travel to the hill towns and Schoharie until the current, gradually curving road was built on the north side of the funeral home around 1912.

Today's Altamont Boulevard was once called South Prospect Street and extended only to the village boundary. In 1921, the state commissioner of highways awarded a contract to Richard Hopkins of Troy, New York, to build a highway connecting Altamont and Voorheesville. Before the 1921 road was built, travelers from Voorheesville followed Gardener Road to Route 146 to get to Altamont. The new highway extended from the Gardener Road intersection north to Helderberg Avenue.

# Three

# COMMUNITY

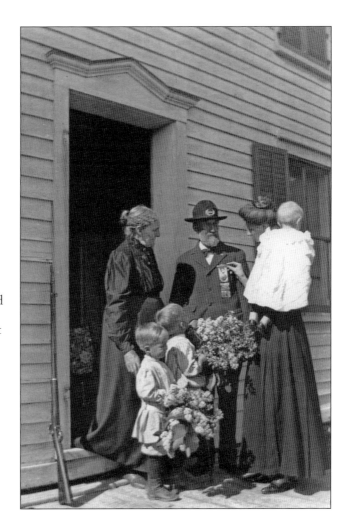

Civil War veteran Peter Ogsbury (1843–1928) is pictured with his wife, Sarah, daughter Margaret, and grandsons Ernest (right) and Raymond Rau at the Ogsbury home. Ogsbury enlisted at age 19 in the 177th Infantry in October 1862 and mustered out as Corporal Ogsbury in September 1863. A Grand Army of the Republic (GAR) ribbon belonging to Peter Ogsbury is in the Village of Altamont Archives and Museum collection, a gift of Everett J. Rau, his grandson.

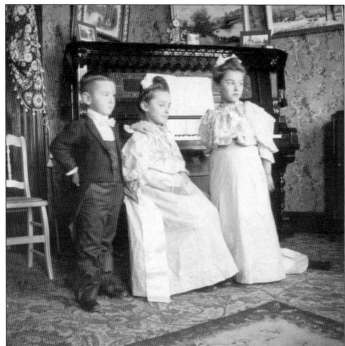

November 21, 1906, was the wedding day of Edna Beebe and Leo Westfall. The children of Irving and Ada Beebe Lainhart, Melvin (left), Melva (center), and Mildred, are dressed and ready at their parent's home at 157 Maple Avenue. The bride's parents, Charles and Amanda Frederick Beebe, hosted the wedding at their home at 117 Maple Avenue.

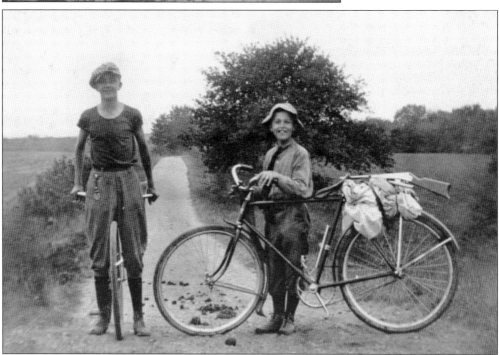

George Boyd Hilton (1899–1986, left) and Frederick Keenholts (1902–1950) enjoy a day of bike riding and perhaps target shooting around 1912. Hilton worked for the Albany County Highway Department and was the father of Boyd C. Hilton, Altamont's first World War II casualty. Keenholts, a longtime insurance agent and three-term village president, was the father of Altamont historian Roger Winfield Keenholts (1943–1992).

James "Jimmy" Johnson, the only village resident listed as "colored" in the 1890 census, came north from Fairfax County, Virginia, in the mid-1860s. He lived in a cabin at the end of Prospect Terrace and worked at blacksmithing and a variety of odd jobs. He was well liked and a respected village resident until his death on Christmas Eve 1903 at approximately 80 years of age. He is buried in Fairview Cemetery.

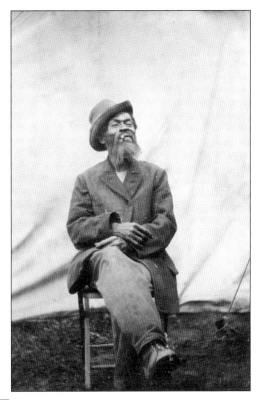

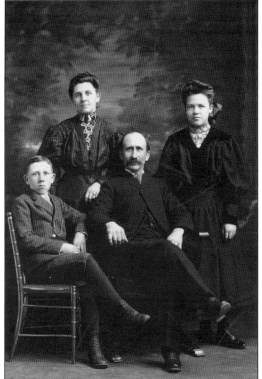

Eugene and Ida Witherwax Sand are pictured with two of their four children, Ivan (lower left) and Ina. In addition to being a talented musician, Eugene Sand was Altamont's president (1905–1906), a longtime member of the Altamont Hose Company, a member of the village board of trustees, Guilderland town supervisor, and an accomplished businessman. He died in 1944 at age 80.

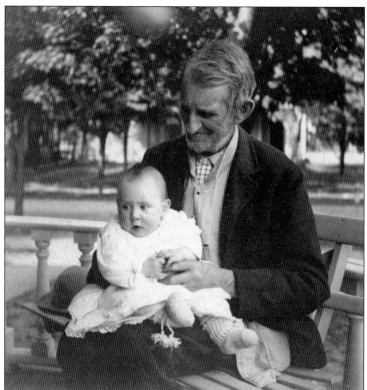

Melvin Beebe (1834–1911) holds his granddaughter Hila Magdaline Lainhart in this c. 1904 photograph. Hila Magdaline was a daughter of Irving and Ada Beebe Lainhart, and Ada was the only daughter of Melvin and Louise Frederick Beebe. Ada Beebe and Irving Lainhart were married at the home of the bride's parents on October 15, 1895. Hila married Myron "Mike" Kaiser on November 6, 1931.

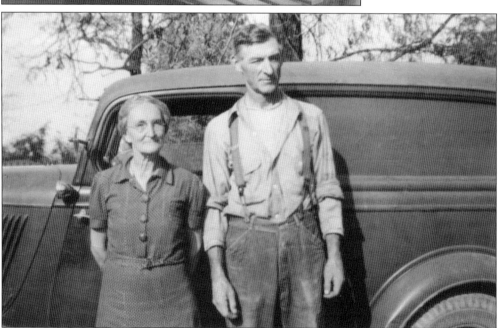

At the age of 10, Arthur J. Crounse was a bellboy at the Kushaqua Hotel on the hill above Altamont. He was later a rural mail carrier and a railway mail clerk. He and Bertha Mae Stalker were married on February 25, 1902, and farmed property on Brandle Road, where they raised their children, Arthur Jr. and Lydia. (Courtesy of Pamela Jones.)

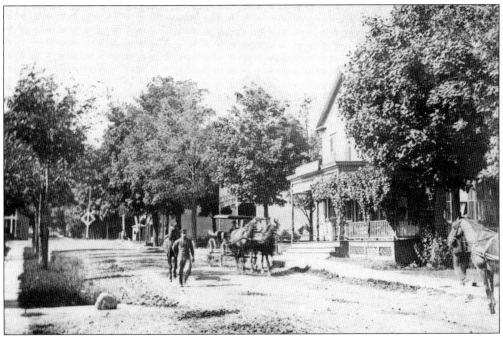

Time changes everything, and the streetscape at the corner of Main Street and Maple Avenue, facing west, is no exception. The one "constant" in these photographs is the railroad crossing diamond, visible in the background. In the undated photograph above, the store to the right of the horses and carriage is Snyder's Store, which opened in 1887. Behind the carriage, across Maple Avenue, is the Pangburn Building. In the photograph below, the banner in the background reads "Albany-Schenectady County Fair, Sept 9-10-11-12-13-14-1929." The Altamont Pharmacy, purchased by Stephan Venear in 1928, is to the right with the gas pump and "Drugs, Soda & Cigars" sign. Next to the pharmacy is Snyder's Store, which closed in 1931. Just visible to the left is an iron fence that once enclosed the entire village park.

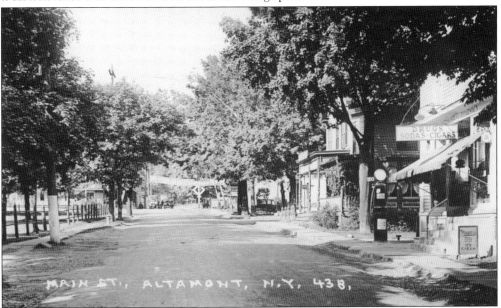

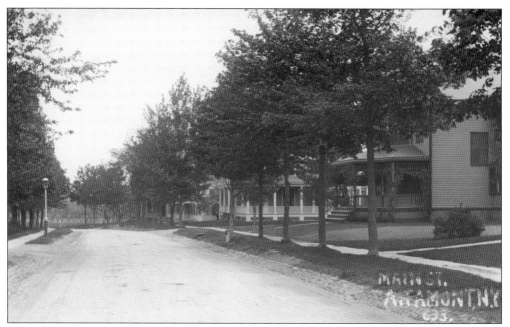

Lower Main Street, with its rows of young, stately trees, appears paved with roughly packed dirt and stone in this early-1900s photograph. The home at the near right is 137 Main Street, built by Edward Crannell in 1905. Beyond it is 139 Main Street, built by William Slabom around 1897. In the distance is an orchard, approximately at the site of Thatcher Drive and the current Altamont Village Hall and Fire Department building.

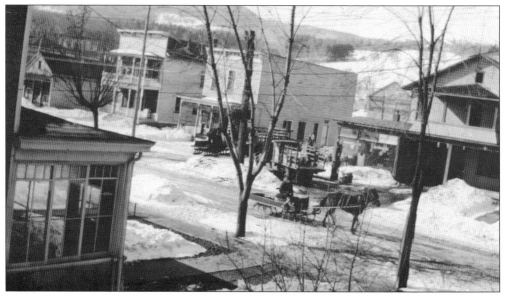

This 1924 winter street scene shows Maple Avenue, with Makely's Garage on the far right. Although Altamont's streets had been named early in the village's development, street signs to help visitors find their way were not erected until the summer of 1935. House numbering proceeded after the signs were installed. House numbers were sold by the Helderberg Post, American Legion, with proceeds going to support the Altamont Boy Scout troop.

This country lane is today called Maple Avenue Extension. The photograph was taken near the corner of what is now Gregg Road, looking north. In the distance is a home built by George W. Coonley, father of Blanche Coonley Blessing. Purchased in 1939 by Edwin and Miriam Sanford, it is currently the home of their daughter, Carol Sanford Du Brin.

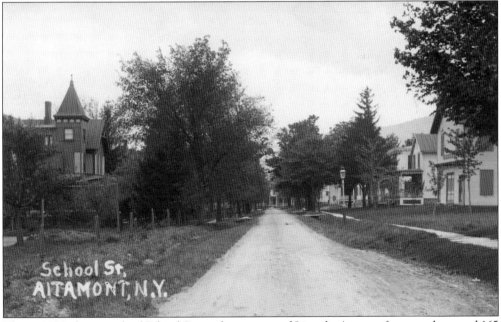

This c. 1890 photograph of School Street, later renamed Lincoln Avenue, faces south toward 165 Main Street, the former Jesse Livingston house. The building on the far right is the Temperance Hall, which became Masonic Lodge 754 in 1895. The home at left, 114 Lincoln Avenue, with its distinctive tower, still stands as a residence.

Brothers Montford and Eugene Sand were born in Knox, New York, the sons of Adam and Louisa Crounse Sand. Montford (left) was born on December 17, 1860, and Arthur Eugene was born on November 14, 1863. The Sand family moved to Knowersville around 1880. In 1884, they purchased property on School Street (Lincoln Avenue) and opened a milling business as Sand's Mill.

Ida May Witherwax (1872–1918) portrays the perfect young lady in this solemn photograph taken around the time her father, Adam Witherwax, purchased the Knowersville House hotel in 1877. She married Arthur Eugene Sand on September 25, 1890, and they had four children, Ina, Ivan, Karl, and Maida.

Leo B. Westfall (1886–1970) and Frank E. Chesebrough (1887–1976) grew up together in Altamont and shared a love of baseball as well as a dedication to their community as firefighters. The photograph to the right, taken around 1902, shows Leo (left) and Frank. In the photograph below, taken around 1912, Frank (right) and Leo are shown as uniformed members of Altamont Hose Co. No. 1. Leo became an engineer and architect. One of his local projects was the design of the Masonic hall, built in 1913 on Maple Avenue. At age 72, he presented to the village a hand-drawn atlas containing detailed village street maps, sketches of water and waste disposal systems, and sketches of public buildings. Frank began employment with the Delaware & Hudson Railroad in the auditing department in September 1902. He retired as head of the railroad's revenue audit department in April 1956.

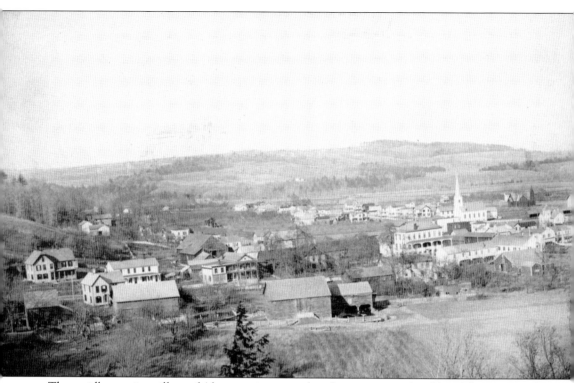

The rapidly growing village of Altamont is captured in this panorama, dated late fall 1888 or early spring 1889. When the first train arrived 25 years prior, this perspective would have revealed only the building housing the former Wayside Inn and the inn's outbuildings, with a couple of farms in the distance. To the right of St. John's steeple is the Altamont Reformed Church, dedicated in October 1888. Note that in the village park (center left), there is no pagoda, or gazebo. The

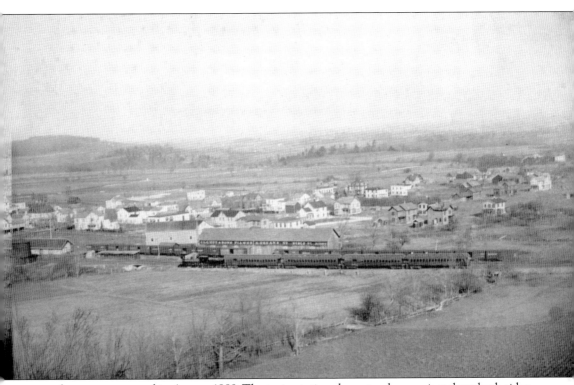

pagoda was constructed in August 1889. The train station shows tracks running along both sides of the building. The park side set of tracks was removed when the new passenger station was built in 1897. The advertisement on the building behind the locomotive and passenger cars reads "Cluett & Sons Pianos & Organs 49 State Street Albany."

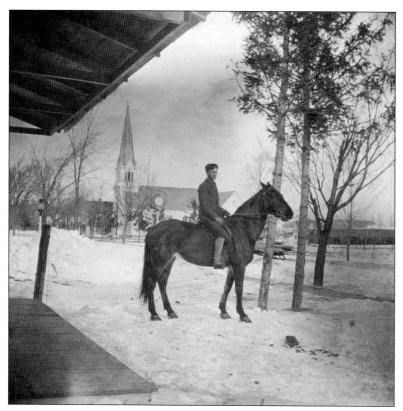

Leo Westfall, 19, is pictured on his horse a year prior to his marriage to Edna Beebe. In the background is St. John's Lutheran Church, built in 1872. This 1905 photograph shows no buildings south of the church, on the east side of Maple Avenue. The structure at left is the porch of the harness shop belonging to Charles V. Beebe, Westfall's future father-in-law.

As teenagers, Edna Beebe and Leo Westfall posed for this photograph in her parents' parlor at 117 Maple Avenue. They were married on November 21, 1906. After years of leadership in the Order of the Eastern Star, Edna achieved the title of Right Worthy Sister, District Deputy Grand Matron. Leo became a renowned civil engineer, honored for his work in Pennsylvania, New York State, and with the Tennessee Valley Authority.

Literacy was important to the first residents, and in 1882, the Knowersville Library Association was organized. By 1888, it had some 400 titles available for lending at 2¢ per week per volume. For a fundraiser to purchase 200 additional titles, the association raffled the latest edition of the Webster Unabridged Dictionary, at 25¢ a ticket. In November 1907, under the leadership of Mrs. Jesse Crounse, 13 ladies organized the Colony Club, a literary and study club whose motto was "What we learn with pleasure we never forget." The club was instrumental in the formation of the Altamont Free Library on May 8, 1916. A series of borrowed and rented locations housed the library, including the back room of the harness shop and the Lainhart Building. The library's current home is the restored train station, built in 1897.

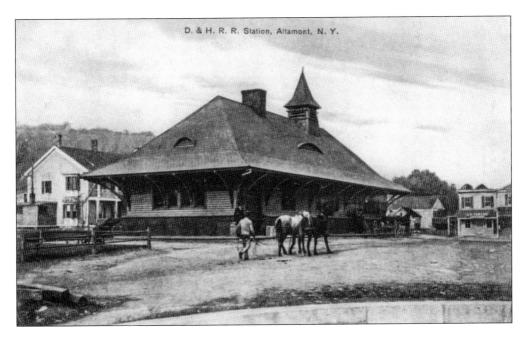

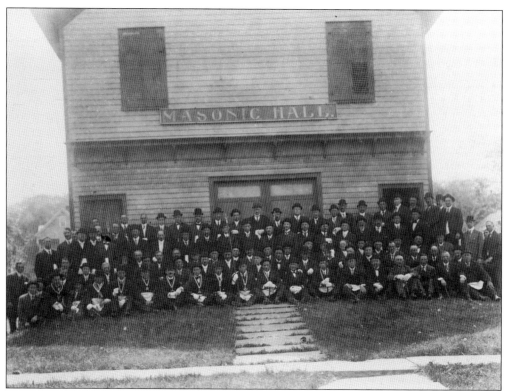

In February 1874, the Grand Master of Masons of the State of New York gave authorization for the formation of the Noah Masonic Lodge 754 in Knowersville. William D. Strevell was appointed worshipful master, Silas Hilton was named senior warden, and James Ogsbury, junior warden. After meeting in various locations for several years, in November 1895, the Masons purchased the Temperance Hall at 115 Lincoln Avenue from the International Order of Good Templars. They remained in this location until 1913, when the lodge secured property on Maple Avenue, next to the Lutheran church. In May 1913, representatives of the Masons (above) and of the Order of the Eastern Star (below) gathered in Altamont to celebrate the laying of the cornerstone for the new Masonic temple, posing in front of the soon-to-be former Masonic lodge.

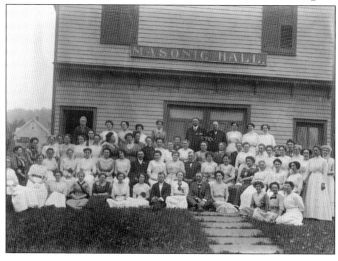

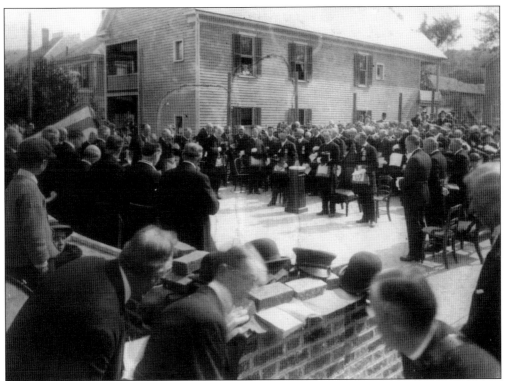

On Saturday, May 31, 1913, with impressive pomp and ceremonies, the cornerstone for the new home of Noah Lodge 754 was laid at 138 Maple Avenue. The architect was Leo Westfall. The stone was laid by Most Worshipful State Grand Master Charles Smith, assisted by many past and current grand officers from across New York State. Many historic objects and coins were sealed in the box within the cornerstone.

On Monday, April 7, 1913, excavation for the foundation of the new Masonic temple at 138 Maple Avenue began. Masonic brothers Ira J. Weaver, a charter member, and W.L. Waterman conducted a short service, declaring the ground broken for Noah Temple 754. Contractor Fred Whitman of Schenectady, New York, was in charge of the work crew shown here and of the erection of the new building.

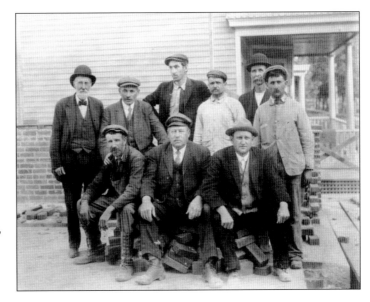

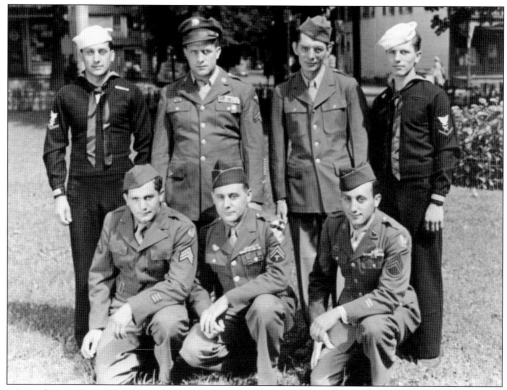

Mr. and Mrs. Peter Orsini's seven sons each served in the US military during World War II. They are, from left to right, (first row) Henry, Nicholas, and Ernest; (second row) Edward, Millard, Michael, and Joseph. Millard Orsini survived the 1942 Bataan Death March in the Philippines and served 41 months in Japanese prison camps. The American flag that he pieced together in secret while a prisoner of war is displayed in Altamont's Home Front Café.

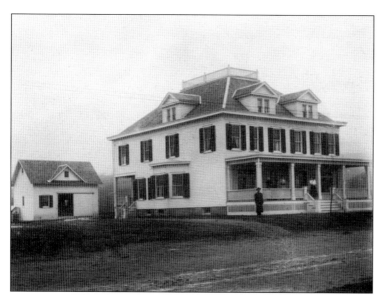

Edward and Hila Sturges purchased the property at 141 Maple Avenue in 1909. Local builder Earl W. Teter constructed their new home, which still stands today. The land was once part of the larger Henry Lockwood estate, which included much of the west side of Maple Avenue. In 1916, Edward Sturges was selected as the president of the first Altamont Free Library Board of Trustees.

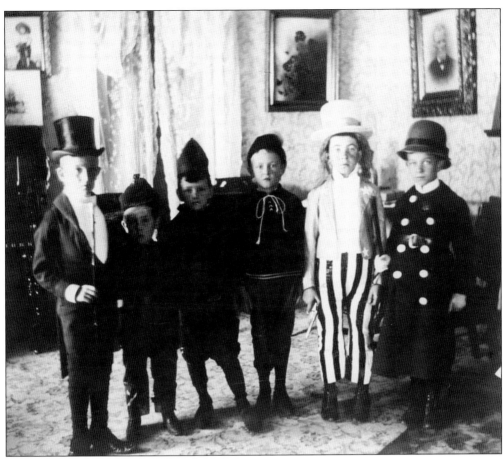

Halloween is an opportunity to dress up and a special time for the young. Pictured in this c. 1900 photograph are, from left to right, Harry Van Aernam, Ivan Sand, Charles Ogsbury, Millard Cowan, Merlin Fredendall, and Willard Westfall. In adulthood, they became distinguished residents of the village, though not necessarily in the careers portrayed here.

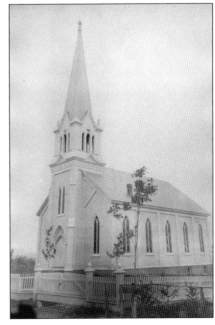

The first Lutheran church in the area was St. James, organized in 1787 and located just west of Osborne Corners, halfway between the communities of Knowersville and Guilderland Center. St. John's Lutheran Church (shown) was the first church built in Knowersville, on land donated by Conrad Crounse. The church was dedicated on March 14, 1872. As the only church until 1888, all denominations were welcomed to worship together.

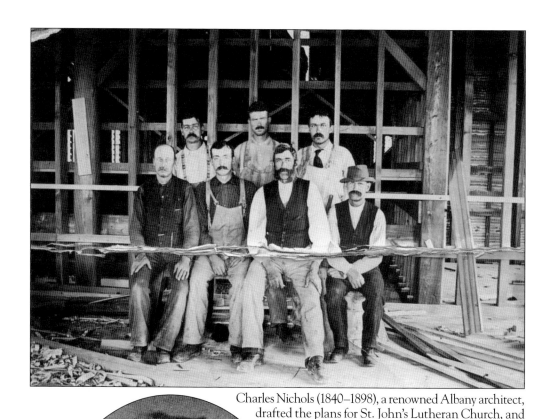

Charles Nichols (1840–1898), a renowned Albany architect, drafted the plans for St. John's Lutheran Church, and those plans were adopted on April 12, 1871. George Rockefeller of Middleburg, New York, received the contract for the construction, and the cornerstone of St. John's was laid on July 11, 1871. The stalwart building crew pictured here was well along with construction at the time of this 1872 photograph.

On October 15, 1875, Rev. A.P. Ludden became the last pastor of the joint congregation of St. John's and St. Mark's. After the churches became independent, he resigned from St. Mark's. Ludden continued to preach at St. John's for another year, until October 29, 1882. He died on April 2, 1892, in Lincoln, Nebraska, where he had moved to be near his son and daughter.

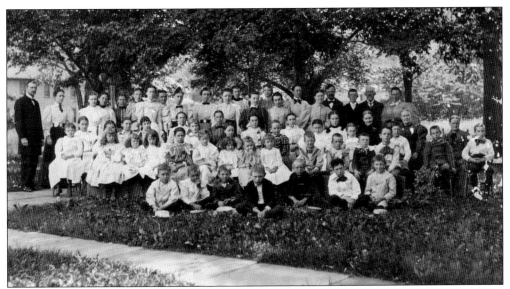

Hardly a smile is displayed in this gathering of the St. John's Lutheran Church Sunday school, pictured on the south side of the church, on what is today the site of the Masonic hall. Rev. Arthur A. Frederick (back row, far left) was the church's pastor for 38 years, from 1894 to 1932.

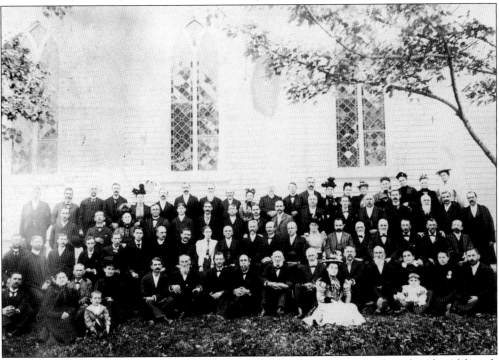

The original St. James congregation divided into two entities, each with a church. Although the Lutherans worshipped in two churches, they remained a joint congregation until October 1881, when they voted to become independent. The congregations of St. John's (Knowersville) and St. Mark's (Guilderland Center) gathered periodically for reunions and to celebrate their common bond from the original St. James Church. This 1898 photograph shows the members of the two congregations.

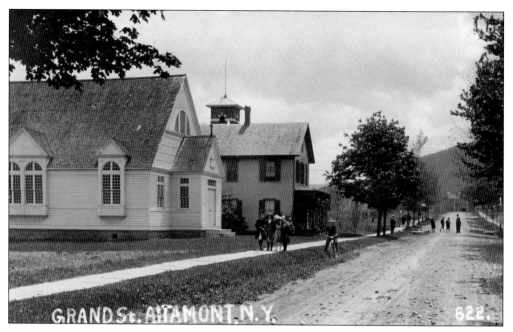

In 1887, Lucie Rochefort Cassidy (1830–1902), the owner of one of the summer mansions on the hill above Knowersville, purchased land of A.A. Tygert on Grand Street. At her own expense, she arranged for the building of a Catholic chapel for the use of the summer residents, their guests, and staff. The chapel (above), located on the east side of the street, was dedicated in honor of St. Anthony of Padua on May 28, 1888. The chapel was renamed St. Lucy's following the 1902 death of its primary patron. Although the first chapel had no heat and few amenities, the congregation grew, and on November 18, 1918, St. Lucy's was incorporated as a parish. Major renovations, including a heating system, were done in early 1922. In 1928, the whole look of the church was altered with the next renovation (below).

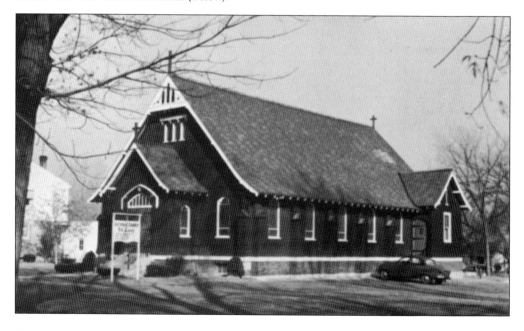

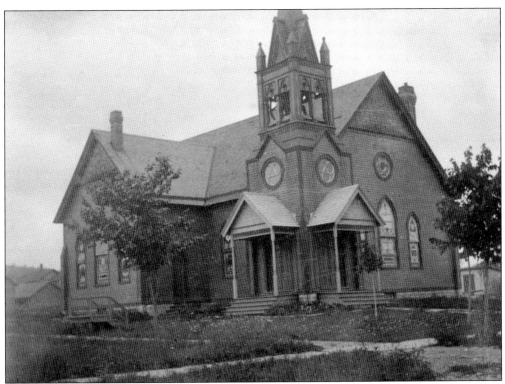

The Altamont Reformed Church (above) was constructed in 1888 by contractor Hiram Schoonmaker on land donated by Melvin Beebe. The building was dedicated on October 3, 1888, and the congregation remained collegiate (shared) with the older Helderberg Church, often called the Gamble Church, in Osborne Corners. The Helderberg-Altamont Church continued for several years, and in 1895, the joint congregation determined that a repair to the old church would be too costly. A new Helderberg Church was built in Guilderland Center. In April 1896, the Altamont Church was formally separated from the shared congregation, and, with 94 charter members, the Altamont Reformed Church was born. The Reverend Bergen Brokaw Staats was pastor through the transition. In 1891, a church hall was built, with sheds for horses and a room for meetings. The parsonage, the building to the left in the photograph below, was constructed in 1897.

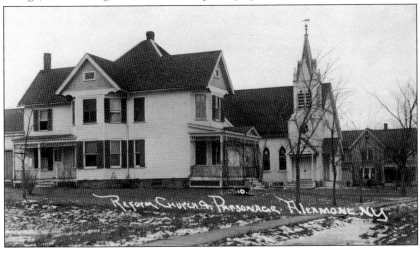

John D. Black first preached to the Altamont Reformed Church congregation in May 1904, just three years after being ordained. He was 36 years old when formally installed as pastor in the Altamont church, in September 1904. After serving as pastor in Altamont until 1908, he moved to Ghent, New York, in Columbia County. He is pictured here with his son Thomas.

Pictured in their Sunday best in 1903 are, from left to right, Mabel Smith, Sadie Staats, Mabel Livingston, and Effie Reid. They were members of the Sunday school class at the Altamont Reformed Church. Sadie Staats was the daughter of Rev. Bergen B. Staats (1853–1947), the last pastor of the combined Reformed congregations of Altamont and the Gamble Church, which stood near what is now Osborne Corners.

In spring 1906, eight girls from the Altamont Reformed Church's Bible class, under the support and guidance of Blanche Coonley Blessing (1874–1961), formed the Laurel Band. Band members dedicated themselves to the study of God's word and to training in Christian service. The band's motto was "We strive to follow Him," and the group's name came from mountain laurel, their class flower. Building friendships and camaraderie, the group initiated many projects and activities to help the church, both spiritually and financially, and to extend a helping hand to the community. Blessing is shown in the photograph to the right and at center with the band below. A college graduate and an active church and community member, Blessing was instrumental in the founding of the Altamont Free Library and served as library secretary for decades. She was also a poet and writer for the *Altamont Enterprise*.

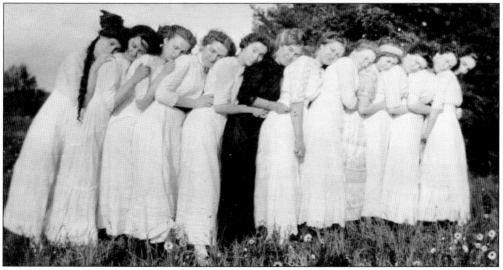

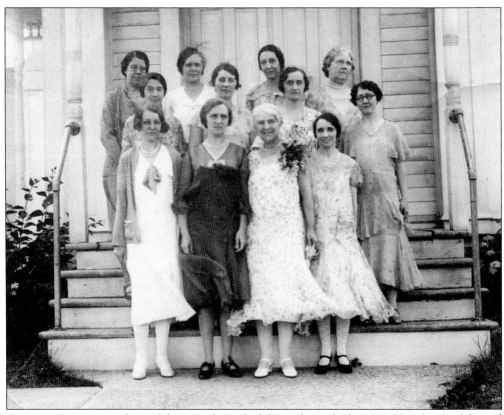

On June 27, 1931, members of the Laurel Band of the Reformed Church Bible school celebrated the 25th anniversary of the band's organization. Starting with nine members, the class roll in 1931 had 105 names. The band's founder and leader for the 25 years, Blanche Coonley Blessing (first row, second from right), was one of the honored guests. This photograph was taken on the steps of the Reformed Church.

The Reverend Bergen Brokaw Staats (center) is pictured around 1895 with, from left to right, daughter Sadie, son Bergen Jr., wife Sarah Cornell, and an unidentified woman. Reverend Staats officiated over the combined congregations of the Helderberg and the Altamont Reformed Churches until 1896, when the congregation voted to become separate entities.

# Four

# GOVERNMENT

Maynard Hilton (left), James DePew (center), and Harry "Mike" Fellows posed for this 1912 photograph wearing their 1909 Altamont Hose Company parade uniforms, which consisted of dark green wool jackets, trousers, and matching caps, all trimmed with red piping. Harry Fellows went on to serve as fire chief from 1919 to 1924. His fire chief helmet is in the Village of Altamont Archives and Museum collection.

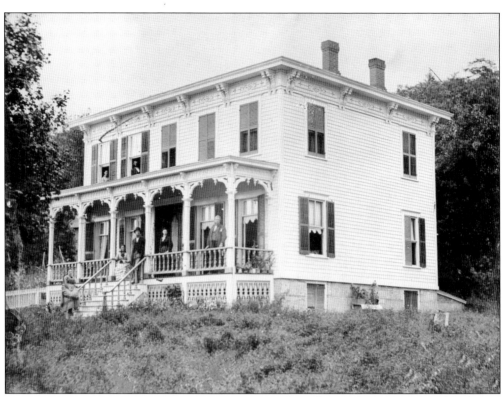

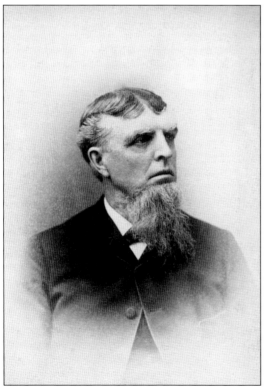

The Italianate home shown in the above photograph was built in 1873 for Hiram Griggs (1836–1909), who is visible in the upstairs window and in the photograph to the left. Griggs opened his law practice in Knowersville on September 30, 1862, and for 47 years, he provided legal counsel and leadership to his village, town, county, and state. From 1867 to 1877, he was supervisor of the Town of Guilderland. In 1877, he was elected to the state legislature, serving three terms. He was a leader in the movement to incorporate the Village of Altamont, which occurred on October 18, 1890. In November 1890, he was elected the first president of the new village; he was elected to seven more terms, serving until 1898. In 1892, Griggs chaired the first meeting to establish the Altamont Fair, and he remained very active in village affairs until his death in June 1909.

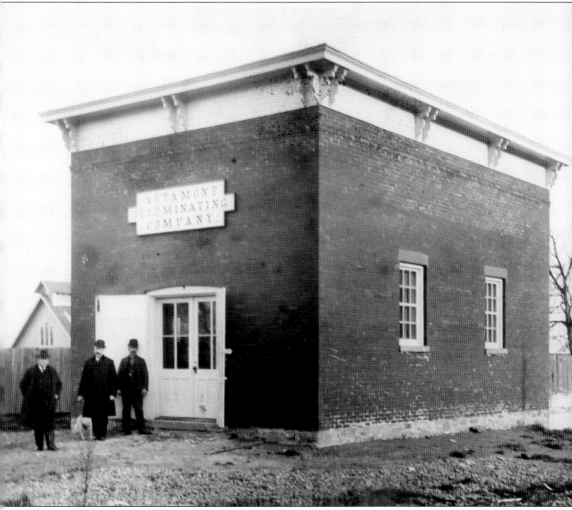

The Altamont Illuminating Company (AIC) incorporated in 1902. The board of directors comprised 13 community leaders, primarily local businessmen. The building shown here was the gas-generating plant, located south of the current Park Street fairground entrance, near the railroad tracks. The gas was distributed around the village via underground pipes for lighting homes, businesses, and streetlamps. By 1914, the Municipal Gas Company of Albany had extended gas and electric lines outside Albany. The potential availability of electricity, its lower cost, and the fact that the summer mansions' owners, many of whom were residents of Albany and were used to having electricity, wanted it for their summer homes, led to the demise of the AIC. In December 1915, stockholders voted to dissolve the company and to sell the franchise to the Municipal Gas Company. By July 1916, Altamont had electricity.

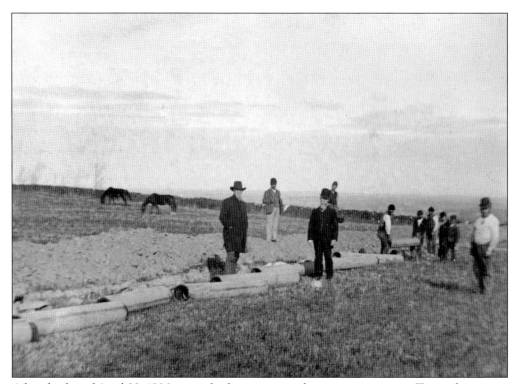

After the fire of April 30, 1886, water for fire protection became more urgent. To pay for a water system, a political entity with taxing authority was needed. The village's 1890 incorporation provided that authority. Shown here in the foreground are, from left to right, Hiram Griggs, Altamont's first president; Dr. Isaac Becker, health officer; and Montford Sand, water commissioner. They are overseeing the installation of the first water line, using pipe made from hollowed-out tree trunks.

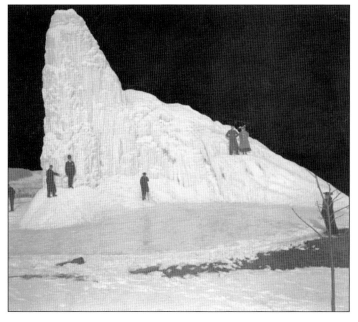

In 1892, the village purchased land in the town of Knox and constructed reservoirs to supply the village with water. The pressure from the piping system resulted in a continuous spray of water. When that spray froze during the winter, magnificent ice towers would form, attracting village residents for viewing and for photographs.

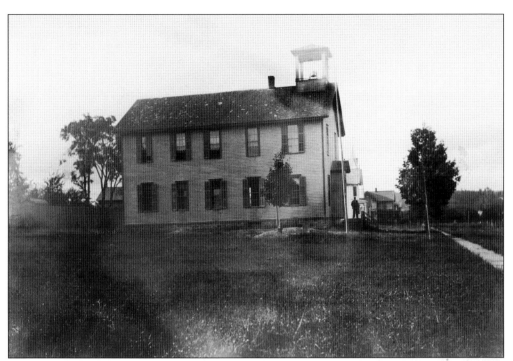

After the school districts in the town of Guilderland were established in 1813, the first school in District Seven was built opposite the Jacob Crounse Inn, on the south side of Old Schoharie Road. The location was approximately the geographic center of the district. The second building was erected around 1864, at what is now 120 Main Street. The structure still stands, extensively modified and serving as a residence. Knowersville soon needed a larger school building for its growing population, and residents wanted one closer to the population center. The third school was built in 1879, on what was called School Street, renamed Lincoln Avenue. The Lincoln Avenue School (above and right) closed after the 1902 opening of the Altamont Union Free School on Grand Street. In 1904, the Lincoln Avenue school building was moved one block west, to 131 Maple Avenue. It is still standing today.

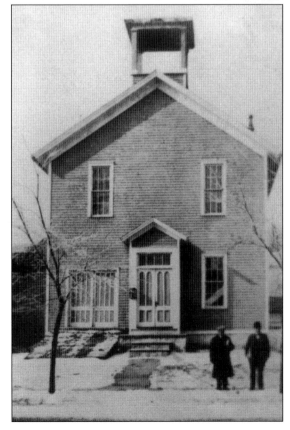

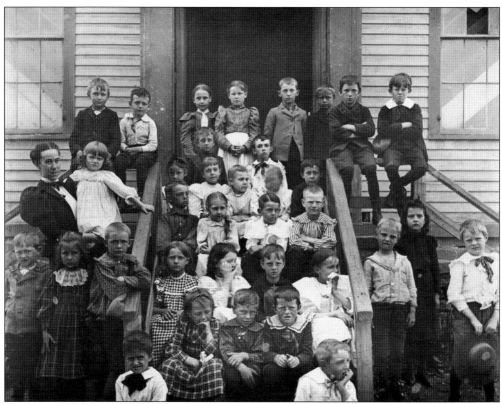

The class photograph above was taken on the front steps of the Lincoln Avenue School around 1890. The boys are dressed in short trousers with long stockings and display a variety of shirt styles, some with wide, elaborate collars. The young ladies are wearing dresses in what was probably a colorful spectrum of materials. Their teacher, identified as Lucy Osborn, is holding one of her younger charges. Osborn taught for many area district schools, including Knox and Fuller's Station. The classroom photograph below shows a very well-dressed group of students, with several of the young gentleman wearing ties. The lack of schoolbooks and papers, with the exception of what may have been an unabridged dictionary on the front desk on the left, may indicate that this was a planned photograph.

88

Shown here are, from left to right, (first row) Altamont High School classmates Neta Tolles (class of 1908); (second row) Irene Lee (class of 1908), Hazel Hogan (class of 1908), and Ethel Hardin (class of 1909). They were part of the school's Alpha Delta Society, a social group whose members would regularly organize school events. Started in 1905, Alpha Delta organized an annual banquet for the graduating class and alumni, a tradition that lasted for many years.

The classic beauty of the old Altamont Union Free School shines in this c. 1907 photograph. Designed by Wheeler D. Wright and constructed by J.W. Packer of Oneonta, New York, in 1901–1902, the building was dedicated on September 18, 1902. The construction was of solid brick with white marble trimmings, and the building had a capacity of 250 pupils. The last class graduated in 1954, and demolition began in 1955.

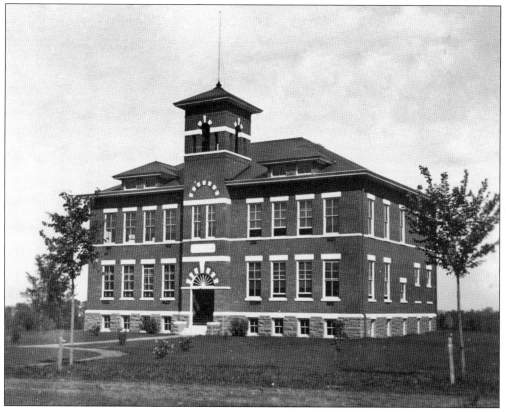

The class photograph above, taken around 1924, contains several members of the graduating class of 1928, pictured below. The Altamont Union Free School on Grand Street housed all classes from its opening in 1902 to its last graduating class of 10 in 1954. The first graduating class in 1905 had 11 members, and class size varied throughout the 50 years of the school's existence. Above, Maida Sand (second row, far left) joins her classmates for their annual photograph. She (1911–1956) was the youngest daughter of Eugene Sand. Below, she is in the first row, second from right. She was valedictorian of her class and went on to graduate from Syracuse University. (Both, courtesy of Laura Phillips.)

Sports were an important part of Altamont Union Free High School. Sophomore John "Jack" Pollard is in uniform and ready to win the game in this 1948 photograph. Pollard went on to become a well-known businessman in Altamont. He and his wife, Cindy, currently own and operate the Home Front Café on Main Street.

The Altamont Hose Company No. 1, founded in May 1893, was the only volunteer fire company in the town of Guilderland for 25 years. In March 1896, Altamont taxpayers authorized the purchase of new uniforms, comprising beige wool frock coats, matching trousers, and caps. The company posed for this 1899 photograph at the Altamont Fairgrounds. A complete 1896 uniform of firefighter Jesse Livingston is in the Village of Altamont Archives and Museum collection.

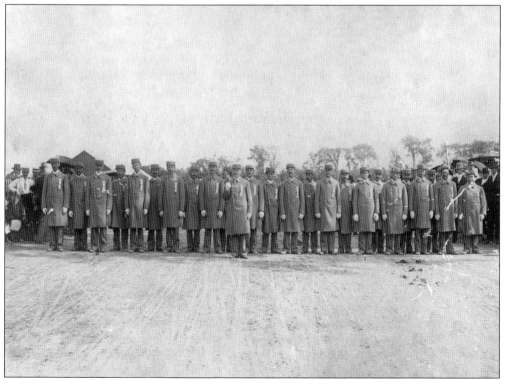

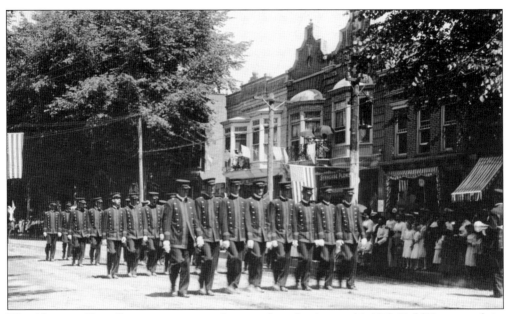

The Altamont Hose Company was invited to march in the August 14, 1912, Field Days parade in Middleburgh, New York. Their dress uniforms, purchased in 1909, consisted of dark green jackets, trousers, and caps, all trimmed with red piping. The group won a silver-plated plaque that day for their appearance and marching expertise.

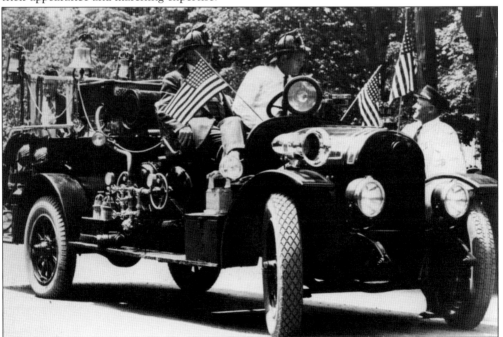

The Altamont Hose Company, organized in 1893, relied on both foot- and horsepower to transport its firefighting equipment, until the 1925 purchase of a motorized fire truck. The American La France truck was built on a Brockway chassis and had tanks for storing firefighting chemicals. It cost close to $4,000, raised largely through contributions. In this 1940 photograph are Frank Lape (left), Clarence Gage (center), and Chief Harry Lewis.

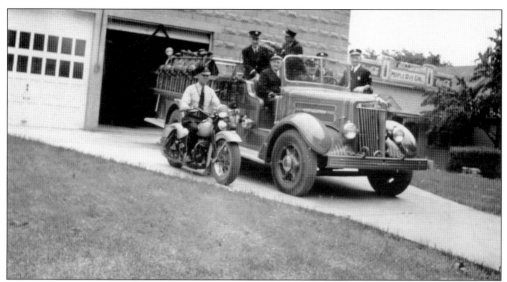

Several large fires in the late 1930s led to the village board in August 1941 authorizing the purchase of a pumper truck for the Altamont Hose Company. The truck, delivered in July 1942, carried a 500-gallons-per-minute water pump. Fire department chief Harry Lewis (1892–1951) is in the left front seat, and Altamont police chief Albert Whipple (1899–1962) is on the motorcycle.

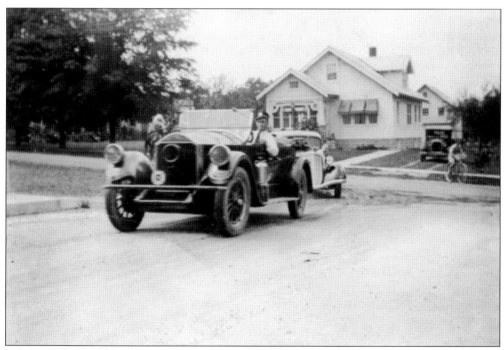

In May 1935, Franklin Townsend, son-in-law of former summer resident Charles Lansing Pruyn, presented this Pierce-Arrow to the fire department for use as a squad car. Behind the Pierce-Arrow is a 1935 Terraplane, which was donated as a raffle prize at the July 19–20, 1935, Hudson-Mohawk Volunteer Fireman's Association convention in Altamont. The winner of the car was Edward Chandler of Knox, who traded the car for a deluxe model Hudson.

From its founding in May 1893, the Altamont Hose Company No. 1 did not have a permanent home until the construction of the fire station (pictured) at 124 Maple Avenue in 1932. Jacob May was the contractor. The hose company was located first in the Temperance hall, 115 Lincoln Avenue (1893–1904), then at the rear of the carriage factory, and later at Keenholts Hall (the relocated Lincoln Avenue schoolhouse).

In March 1937, a total of 15 members of the Altamont Hose Company signed up for and passed a required Red Cross first aid course, leading to the July 1937 establishment of the Emergency Relief Squad, precursor to today's Altamont Rescue Squad. Harry Fredendall, the owner of Altamont's funeral home, donated a used Hudson hearse (pictured) for use as a transport vehicle for the relief squad.

## *Five*
# A Summer Retreat

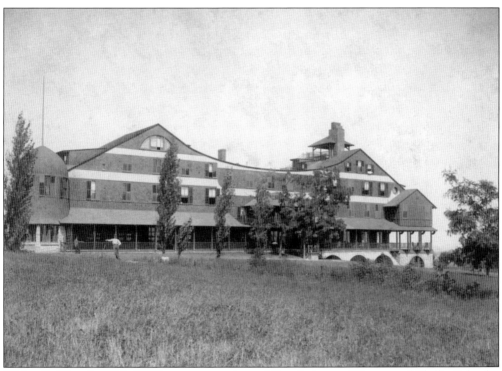

Walter S. Church (1813–1890), a great-grandson of Revolutionary War general Phillip Schuyler (1733–1804), built Kushaqua in 1885 on the hill above Altamont. The hostelry was very successful, and in 1887, Church built an addition to the already grand structure. Church died in 1890, and in 1892, Frederick J.H. Merrill, noted geologist and director of the New York State Museum in Albany, purchased Kushaqua for use as a private residence.

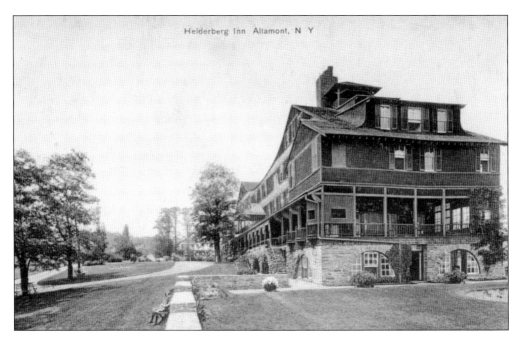

In 1902, Frederick J.H. Merrill leased the Kushaqua to H.P. Smith, who once again opened it as a hostelry, under the name Helderberg Inn. Smith developed a brochure for the inn, which included the photograph of the Main Hall shown below. In 1907, a syndicate consisting of the owners of summer mansions adjacent to the inn purchased the property to ensure that the conduct of the hotel should be to their liking. Managers came and went, and the inn remained open. In 1911, manager George T. Clapham hosted a number of Altamont's businessmen for a night of dining and bowling. By 1915, the name had changed to the Helderberg Golf Club, sometimes called the Helderberg Country Club. The club was sold at auction to Frank A. Ramsey of Albany in 1917 for $9,100, a fraction of its value.

After opening in 1885, the Kushaqua resort and hotel quickly developed a reputation for providing the best and most up-to-date lodging and sanitary facilities. Because it was a summer resort, the farms in the surrounding area provided a bounty of fresh foods for the guests, as indicated by this August 16, 1887, dinner menu. There would have been little opportunity to go hungry.

In 1918, the Catholic Diocese of Albany purchased the old Helderberg Inn for use as a summer residence for the Sisters of Mercy. In 1921, the Reverend Simon Forestier, in the name of the Missionaries of Our Lady of LaSalette, purchased the property. After extensive renovations, it was transformed into the LaSalette Seminary (pictured). The wooden structure was destroyed by fire in 1946.

### The Kushaqua,

MONDAY, AUGUST 15TH, 1887.

**DINNER**

Little Neck Clams on Shell.

**Soup.** Mutton Broth with Barley.

**Fish.** Point Shirley Rock Cod.
Saratoga Potatoes.  Sliced Cucumbers.  Sliced Tomatoes.

**Boiled.** Chicken, Egg Sauce.  Smoked Tongue.

**Roast.** Sirloin of Beef au jus.
Stuffed Spring Chicken, Giblet Sauce.
Mutton, Jelly Sauce.

**Entrees.** Lamb Cutlet, à la Soubise.
Chicken Pot Pie, à l'Americaina.
Pear Fritters, Glacé au Rum.

**Mayonaise** Chicken.  Lettuce.  Tomatoes.

**Relishes.** Chow Chow.  Mixed Pickles.
Olives.  Worcestershire Sauce.
Tomato Catsup.

**Vegetables.** Boiled New Potatoes.  Mashed Potatoes.
New Green Corn.  Lima Beans.
Marrow Squash.  Boiled Beets.

**Pastry.** Cabinet Pudding, Wine Sauce.
Apple Pie.  Orange Pie.

**Dessert.** Lemon Sherbet.  Jelly Custard.
Assorted Cake.  Watermelons.  Oranges.
Layer Raisins.  Bananas.
Assorted Nuts.  Edam Cheese.  Coffee.

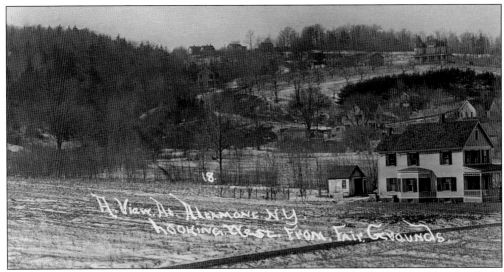

In 1893, James Bleecker Groot (1848–1914) built his "house on the hill," shown at upper right in the above photograph. Groot was in poor health for much of his life, but he was mechanically inclined, and his hobby was manufacturing intricate clocks of his own design. He shared the house with his sisters Katherine and Elizabeth. Ownership passed to Raymond W. Carr, a Delaware & Hudson lawyer, and later to Frank B. Carpenter, a longtime Woolworth executive, who named the property Breezy Brow. In 1947, the structure was refurbished into the Wagon Road Inn, and in 1960, the Branigan family opened it as the Altamont Inn. The Vlahos family purchased the property in 1964 and opened the very popular and successful Altamont Manor restaurant, operating it until 1982. Today, the Altamont Manor is a banquet facility, still owned by the Vlahos family. (Below, courtesy of Harvey Vlahos.)

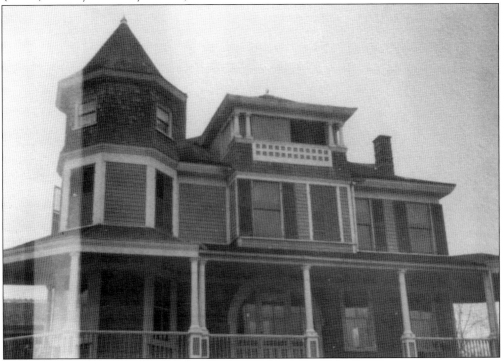

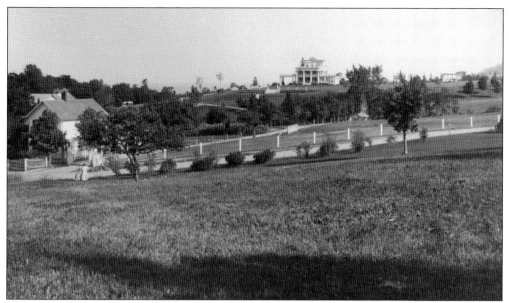

Albany merchant Paul Cushman (1822–1895) purchased land in 1891 and built his summer home above Altamont in 1893. Unfortunately, he was unable to enjoy his mansion for long, succumbing to pneumonia on June 3, 1895. John Boyd Thacher (1847–1909), a former mayor of the City of Albany, purchased the home in 1900, extensively remodeling the original structure. The John P. Sewell family purchased the mansion after Mayor Thacher's death, leaving after the death of their daughter Mary in 1939. The structure, vacant for many years, was purchased by the Catholic Diocese of Albany. The diocese, planning to erect a new building on the site, asked the Altamont Fire Department to burn down the structure, both as an economical method of removing it and as a training exercise for the department. The "White House of High Point" burned down on January 30, 1965.

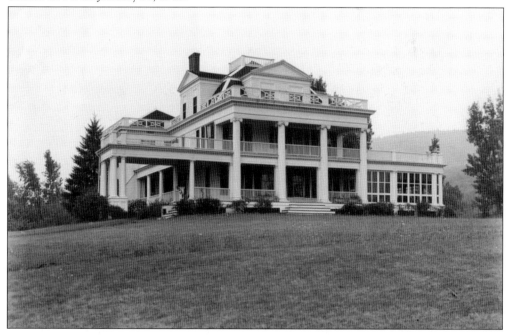

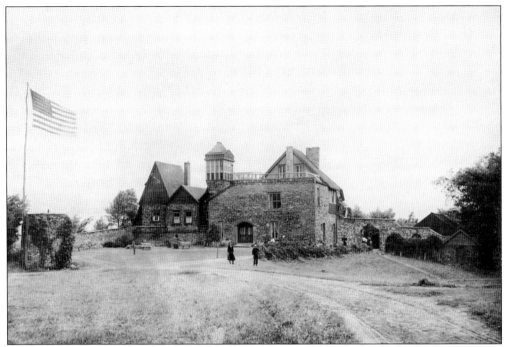

Edward Cassidy (1862–1948), an accomplished Albany architect and son of William and Lucie Rochefort Cassidy, built the elaborate stone and wood "castle" around 1890 on the hillside west of Altamont. The structure burned down in 1949, after being used as a young women's summer camp for years. A portion of the land and remaining buildings are today the site of Camp Lovejoy, owned by the Schenectady Boys Club.

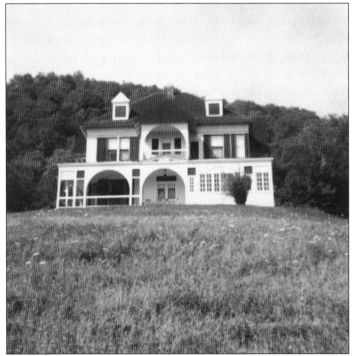

In 1887, Margaret Fenelon, an Albany seamstress, built a handsome home on a portion of Azor Livingston's (1849–1916) land near the end of what is now Leesome Lane. A breach-of-promise suit between Livingston and Fenelon, and the resulting legal fees, eventually exhausted her savings, and she gave up the cottage. In 1982, owners Donald and Emma Aumic were successful in having the property placed in the National Register of Historic Places.

Charles Lansing Pruyn (1852–1906) was a wealthy Albany philanthropist who gave liberally of his time, money, and abilities to further business and education in his home city. His father, Robert, was the first US envoy to Japan. In 1889, Charles built a 19-room mansion on the hillside above Altamont. After his death, his family retained ownership until his daughter Jane Pruyn Townsend sold the property in June 1961. (Courtesy of Ron Ginsburg.)

In 1885, Lucie Cassidy, widow of William Cassidy, editor of the *Albany Argus* newspaper, built her summer home in Knowersville. In 1887, she purchased land on Grand Street and built St. Anthony's, a Catholic chapel, later renamed St. Lucy's in her honor. Among her summer guests was governor and future president Grover Cleveland, who had the final say in the village's name change from Knowersville to Altamont in 1887. (Courtesy of Ron Ginsburg.)

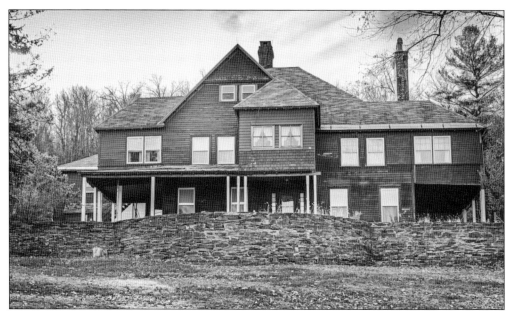

New York State Supreme Court justice Rufus W. Peckham (1838–1909) built Coolmore, his Knowersville summer home, in 1885. Pres. Grover Cleveland appointed Peckham to the US Supreme Court in 1895, and he died at Coolmore in 1909. Utilities magnate Bernard C. Cobb (1870–1957) purchased the property in 1930, renaming it Woodlands. After Cobb's death, his daughters donated Woodlands to the Albany Catholic Diocese, which opened a school to educate and support handicapped children. (Courtesy of Ron Ginsburg.)

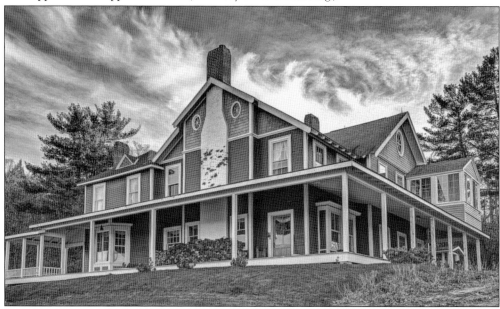

James D. Wasson (1842–1912), a prominent Albany businessman, banker, and a recognized authority on real estate values, built his summer residence, Mira Vista, in Knowersville in 1872. He married Mary Cooper Jenkins in 1867, and they had four children. His daughters Mary and Jennie continued to occupy Mira Vista well into the 1960s, maintaining a very active civic and social life in the village. (Courtesy of Ron Ginsburg.)

# Six
# Rest and Recreation

High Point is a natural rock ledge on the Helderberg Escarpment high above Altamont. A group of hikers, complete with walking staffs and hats, gathered on July 5, 1892. This photograph was taken by Allen J. VanBenscoten, a resident of Altamont. The climb, up a rather steep cliff, could not have been an easy one while wearing the shoes and skirts in fashion at the time.

Few villages in the late 19th century were without a band or an orchestra, and Knowersville was no exception. The two groups often shared the same individuals and instruments, with the band taking an "outside" or parade role, and the orchestra, with the addition of a few stringed instruments, providing "inside" or sit-down winter entertainment. There were usually a series of summer concerts in the village park, and a parade simply could not happen without the band. Both groups were in demand along the Albany & Susquehanna Railroad corridor. Some of the village's better-known residents were members of one or more of the music groups, such as architect and beekeeper Wheeler D. Wright. Village president, businessman, and trombone player Eugene Sand is at far left in the above photograph of the Cornet Band. He is in the second row, second from right, in the photograph below of the Knowersville band.

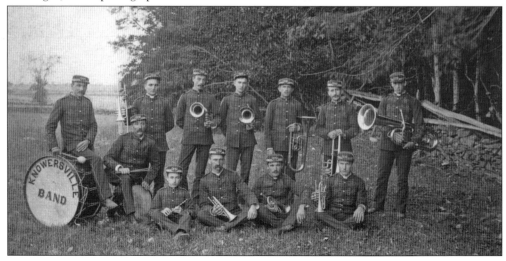

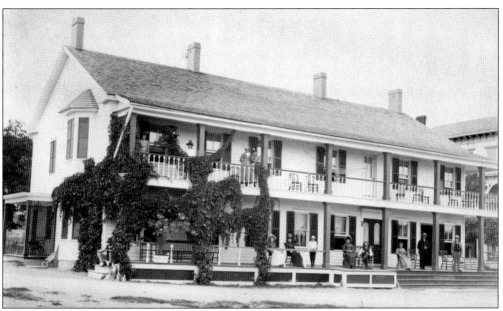

George Severson, a great-grandson of Jurrian Severson, built the Severson House hotel in 1867. John Stafford (1827–1887) purchased the hotel in 1869 and changed the name to the Union Hotel. Above, Stafford's family poses on the porches of the hotel. On the lower porch are, from left to right, an unidentified woman; John Stafford's daughter Mary (Mrs. W.D. Wright); her son Leroy; John Stafford's daughter-in-law Helen Stafford; her son Chatfield; John's wife, Maria; an unidentified man; and John Stafford, who died in 1887. The hotel remained in the family until 1894, when James Keenholts swapped his Prospect Terrace property with Maria, the widow of John Stafford, for the hotel and changed the name to the Commercial Hotel (below). After several changes in ownership, William H.K. "Dutch" Cornelius (1865–1932) bought the property in 1903, owning it for nearly 20 years. The structure was demolished in 1942.

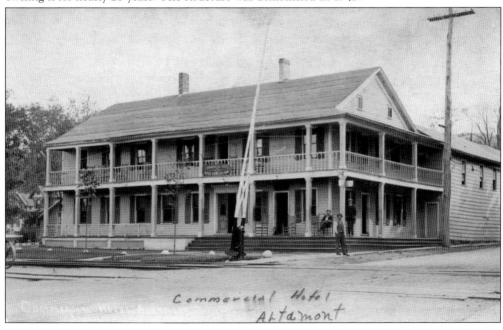

William "Dutch" Cornelius and Georgiana Rector purchased the Commercial Hotel in 1903, operating it for nearly 20 years. Although a respected hotelier, "Dutch" was convicted of "embracery" (jury tampering) in a 1912 case and was sentenced to three months in jail and a $300 fine. New York governor Martin Glynn commuted the sentence in 1914. The couple posed for this undated photograph, perhaps at the photo booth at the Altamont Fair.

The bar at the Commercial Hotel was undoubtedly a popular gathering place, evidenced by the boxes of cigars and the many bottles of whiskey behind the bar. However, Prohibition cut into the profits of many a hotelier. This hotel was converted to apartments after it was sold by "Dutch" Cornelius in 1920.

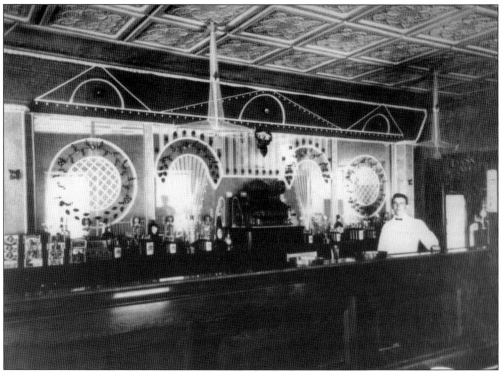

The theme of this 1903 Fourth of July float is "American Beauties," and the young ladies, standing proud, certainly embody the concept. For the 1903 celebration, the floats gathered on the fairgrounds at 10:00 a.m. The parade, sponsored by the Altamont Hose Company, started at 10:30. Willard J. Ogsbury (1882–1963) is handling the reins. The marshal for the day was John T. Severson (1863–1947), grandson of George Severson.

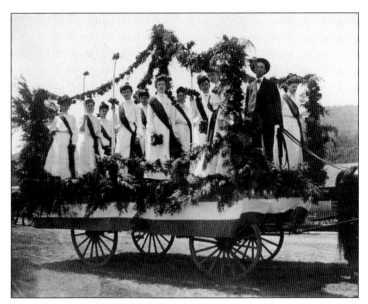

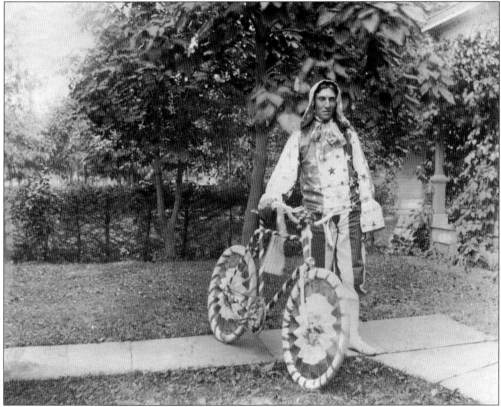

It was not just another Saturday night, but most likely a Fourth of July parade that prompted Walter Severson (1877–1953) to decorate himself and his bicycle so completely. He married Effie Reid, and they had a daughter, Mary Elisabeth. He was employed for most of his life by G.B. Lewis, a Watertown, New York, company that manufactured beehives and related equipment. He retained an interest in beekeeping long after retirement.

Albert "Bert" Rector (1874–1968) worked for his brother-in-law "Dutch" Cornelius as the manager of the Commercial Hotel, pictured in the background. He learned the plumbing and heating trade in the employ of Manchester Plumbing Co., developing an artisan's reputation for his excellent work. He was a Mason for 64 years, having been born just three months before Noah Lodge 754 started in Knowersville in 1874. He died in 1968 at age 94.

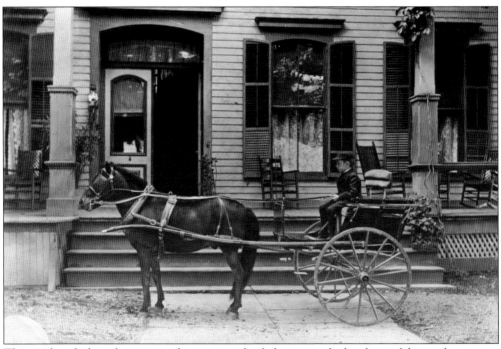

This unidentified youth in a pony-driven, two-wheeled cart is parked in front of the south entrance to the Altamont Hotel. Built in 1876 by James Ogsbury as the Knowersville House, the hotel's name changed in 1893 to reflect the village's new designation. The hotel used the cart to transfer traveler's luggage to the hotel, a short walk from the train station.

The Knowersville House, built in 1876 by James Ogsbury as a hotel, was sold within a year to Adam Witherwax, who then rented the hotel to James O. Stitt in 1888. Stitt subsequently purchased the hotel in March 1890 and changed its name to Hotel Altamont in 1893. In 1900, he leased the hotel to Abram D. Witt for a five-year period and later sold the hotel to Julius Voss in April 1907. New York governor Theodore Roosevelt and his family were frequent guests, and the hotel was a popular destination for both out-of-town visitors and residents of Altamont. In March 1928, the top floor of the hotel was severely damaged by fire, and Julius Voss did not reopen the hotel to guests. In 1935, it was demolished, and a gas station sits on the site today.

In 1888, the Delaware & Hudson Railroad offered the village the use of vacant land adjacent to the train station as a park. By September 1889, a pagoda had been constructed, and it quickly became the site of Altamont Band concerts, picnics, ice-cream socials, and other gatherings. Despite many reconstruction and stabilization efforts, the old wooden structure was finally laid to rest in June 1947. (Gift of Guy J. Gamello Jr.)

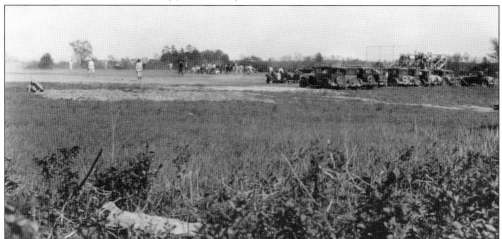

Early in 1929, a group of Altamont businessmen met and discussed the need for a recreation field for the village. Their interest turned into action, and the Altamont Athletic Association was organized and incorporated, and officers were elected. The association purchased 16 acres of land off Dunnsville Road from Walter Armstrong, and in May, the first baseball game was played on the new field (pictured).

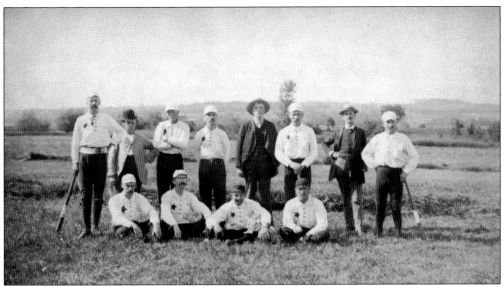

The sport of baseball is mentioned often in written accounts of Altamont's history. Posing with the team in the above photograph, taken in the late 1890s, are former village presidents Montford Sand (second row, second from left) and Hiram Griggs (second row, fourth from right). The Altamont team played in various leagues, including the Susquehanna, the Helderberg, and the Suburban. The photograph below, taken at the fairgrounds, shows the original grandstand and judge's platform in the background. In 1915, Altamont's team was the Susquehanna League pennant winner, meriting a front-page photograph in the *Altamont Enterprise* and an offer for fans to procure copies of the image from itinerant photographer L.I. Hall at the Hotel Altamont. Baseball and the team's activities were often front-page news in the *Enterprise*, sometimes occupying two full columns of details about the game.

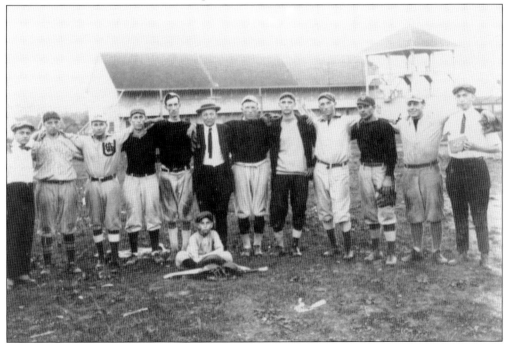

The Altamont Gun Club, formed in 1926, provided recreational shooting for members for nearly 35 years at its clubhouse (above), at what is today 6420 Gun Club Road. At the club's 30th anniversary celebration, Mildred Fick, club secretary and treasurer, affirmed that the club was the oldest active rod and gun club in the state. It was also the first club in New York State to shoot under lights. In 1930, a contract awarded to the General Electric Company in Schenectady, New York, provided the electric lighting for night shooting (below). The shooting club disbanded in 1961. The old clubhouse, converted to a residence but derelict today, still stands on Gun Club Road.

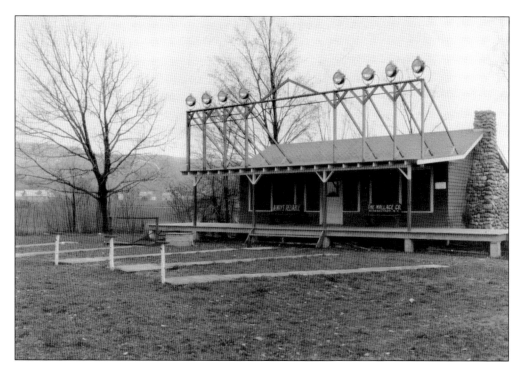

Maple Avenue was once called Church Street, after St. John's Church. In March 1888, once the building of the Catholic chapel and the Reformed Church was under way, many residents felt their street had lost its uniqueness, and they sent a petition to the *Enterprise* asking that the name be changed to Maple Avenue. In the next issue, the *Enterprise*, as the village's "voice," agreed with the petitioners, and the change was made.

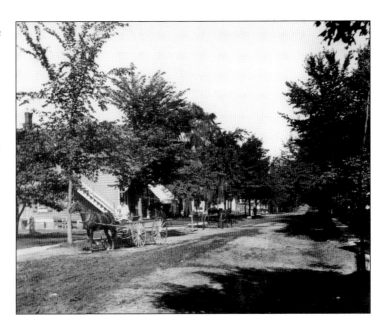

This young gentleman has either stepped in something unpleasant, or he is prepared to flatten a targeted object. The photograph was probably taken along School Street, just north of the school, facing east. The scene appears to reflect summer, but the children are well dressed, including boots and shoes. The cart may have been designed for double duty as a dog cart as well as for kiddie transport.

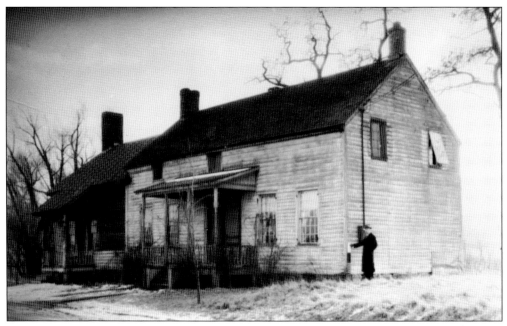

The oldest residence in the village is located at 271 Brandle Road. The house, noted on the 1767 map of the West Manor of Rensselaerwyck, was built by Jurrian Severson, who relocated to the area around 1745. He married Elizabeth Groot in Schenectady in 1727. The old Severson burial plot is located across the street from the house.

Jane Beebe (1864–1955) was the sister of Charles V. Beebe, Altamont's premier harness maker. Her outfit may have been influenced by Annie Oakley (Phoebe Ann Moses), who appeared with The Buffalo Bill Wild West Show in Albany on May 29, 1900. Jane Beebe married Palmer Cleveland in 1904, and the couple moved to Scotia, New York, returning to Altamont in 1943.

# Seven
# THE FAIR

New York governor Benjamin Odell (standing, center) addressed the attendees at the fair on August 27, 1903. He was joined on the viewing platform by many of Altamont's businessmen and politicians. James Keenholts (1868–1912) is standing to the right of the governor, and former village presidents Montford Sand (seated, far left) and Hiram Griggs (seated, third from left) were among the attendees.

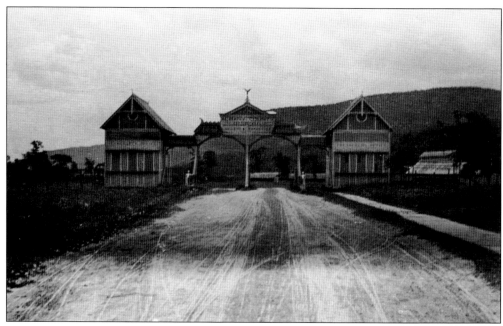

The Albany Agricultural Society sponsored the first fair in Albany County in 1819. For the next 70 years, fairs continued to be held in the city of Albany and surrounding towns and villages. In August 1892, discussions began about locating the county fair to Altamont, a fitting recognition of the rich agricultural heritage of the area. The incorporation of the Altamont Driving Park and Fair Association, as it was first known, was approved on May 20, 1893. For the next four months, countless meetings occurred, committees were established, land was acquired, a racetrack was laid out, buildings were contracted and built, and on September 12, 1893, the first Albany County Fair at Altamont opened. An entrance gate and a grandstand (below, in the distance) were among the first buildings erected. A new entrance gate (above), including offices for the treasurer and secretary, was built in 1901.

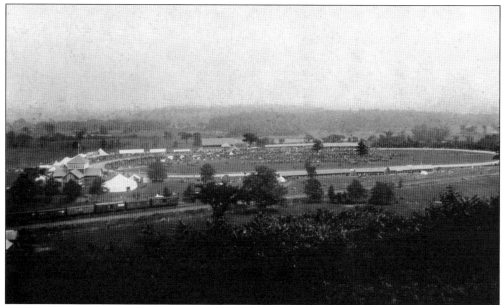

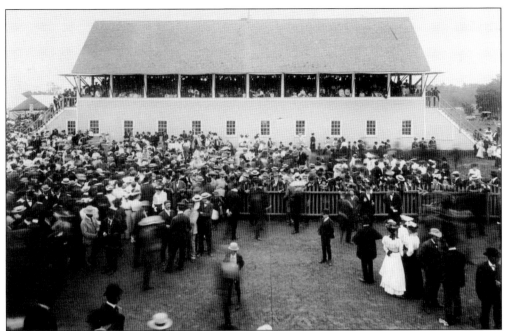

The first permanent structure built on the fairgrounds was a grandstand (above), constructed in the summer of 1893, prior to the first fair's opening in September. The grandstand, 100 feet long, was accessible by stairways at both ends. The original contract award for the grandstand and an entrance gate went to Howard P. Foster, but when he was unable to complete the contract, the fair's board of directors asked superintendent of grounds James Keenholts to finish the project. Keenholts's bills totaled $2,152 for the completion. A 12-foot-by-12-foot, tri-level judging stand (below) was erected in 1897 opposite the grandstand. The judging stand provided an excellent perspective for the horse races, a part of the fair since 1893, and for auto racing, which began in 1910. The stand was demolished in the mid-1950s.

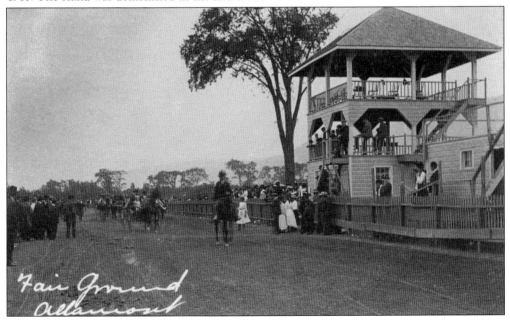

In 1925, a new grandstand was built by the Evert W. Hurme Construction Company on the west side of the fairgrounds. The bid was $18,600, and the new structure would seat 3,000. The original 1893 grandstand was 100 feet long, and, although an additional 60 feet had been added in the early 1900s, it was simply not large enough. The new one was significantly larger, as can be seen in the above photograph, with exhibition and storage space beneath the bleachers. Also, the manner of dress for the fairgoers changed as the times evolved, as can be seen in the photograph below of the grandstand, taken around 1950. The 1925 grandstand was destroyed by fire in November 1995. Wind-driven rain shorted a fuse box within the building, and the 70-year-old largely wooden structure quickly burned to the ground.

Agriculture may have been the focus of the early fairs in Altamont, but horse racing was a passion. The half-mile oval racetrack was completed in July 1893, before the grandstand and entrance gates. Local businessmen owned or had shares in horses, and the abilities (or lack thereof) of the horses were widely discussed. Races were held regularly throughout the summer months, not just during the fair.

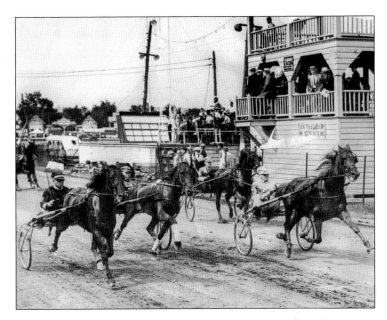

During the planning for the 1924 fair, the board of directors decided to open the event for two evenings during the five-day run, for the first time since the fair began. People unable to attend during the day had the opportunity to visit after work, and all the shows, rides, and other attractions were open in the evening. Fireworks, another first, were offered on both nights.

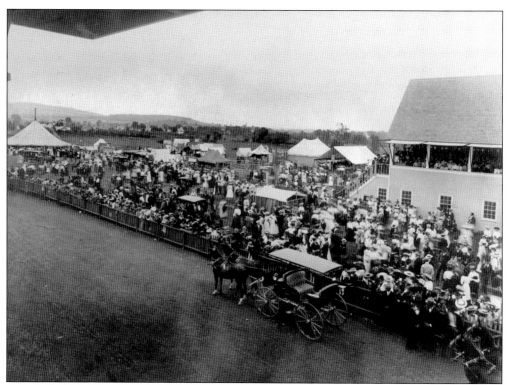

A carriage "drive–by" exhibition is the focus of attention for many in the well-dressed crowd at the fair in August 1903. Some of the carriages on display may have been made at the carriage manufactory, then owned by Keenholts & Whipple on Maple Avenue. In the above photograph, the north end of the original grandstand, built in 1893 prior to the opening of the first fair, faces toward the railroad tracks and the hillside west of Altamont. The lower part of the original grandstand was incorporated into the building used today for poultry exhibitions. Visible in the photograph below, to the left of the racetrack, are the horse barns still in use today.

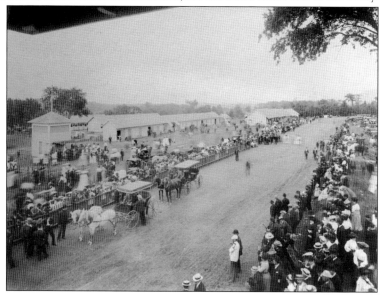

The *Altamont Enterprise* reported on June 19, 1896, that "Hiram Schoonmaker has the contract for building a new exhibition hall on the Fair ground." The article further stated that Albert Manchester "will do the roofing, which will be of slate," and Crannell Bros. will provide the lumber. Completed before the fair opened that September, the Flower and Fine Arts Building is listed in the New York and National Registers of Historic Places.

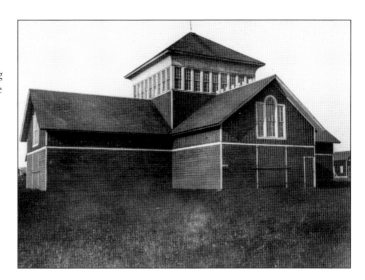

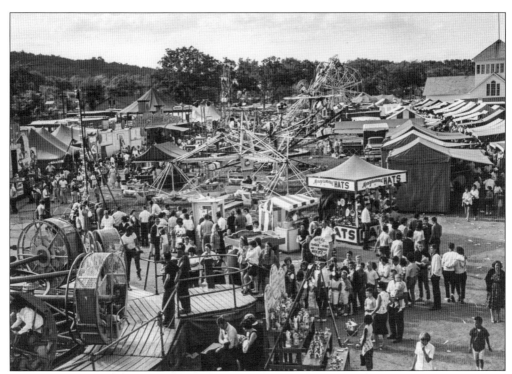

The one constant landmark in the Altamont Archives' collection of fair images is the Exhibition Hall/Flower and Fine Arts Building. It is depicted in the 1903 photograph on the book's cover and in this c. 1950 photograph. A midway, with mechanical rides and carnival barkers' tents, has replaced the open spaces, and the Flower and Fine Arts Building, still in use today, appears in the background at right.

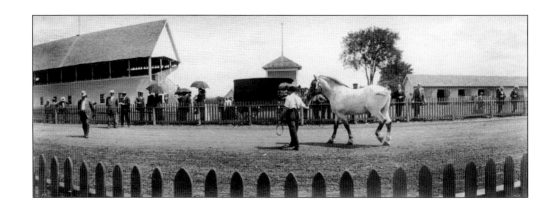

As teenagers at the turn of the century, Evelyn and Rose Foll of Albany began experimenting with the science of photography, developing and printing their own photographs. The new fairgrounds and the gatherings of people and animals provided many opportunities for a young photographer. Evelyn acquired a new panoramic camera, possibly a Model No. 1 Panoram Kodak, which would take vista, or wide-perspective photographs. She brought her new camera to the Altamont Fair. The camera was designed to take photographs at waist height, providing a unique vantage point. It produced the unusual photographs above and below. Evelyn Foll died in 1942, and her daughter Margaret Hout donated her story and photographs to the Altamont Archives.

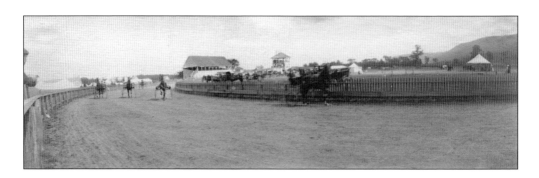

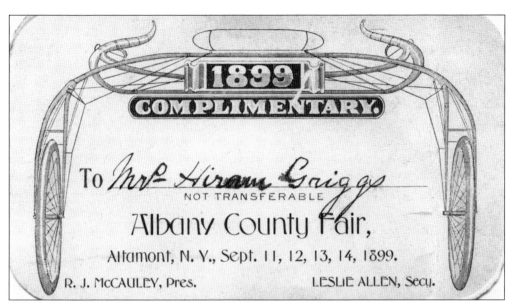

The 1899 Albany County Agricultural Society and Exposition was held September 11–14. The fair had come a long way in seven years, with permanent buildings for most of the exhibits and a racing program for every day of the fair. Hiram Griggs had been elected the first president of Altamont in 1890, and he served a total of eight one-year terms, earning a complimentary pass to the fair.

The 46th annual Altamont Fair was held August 22–27, 1938. The August 19, 1938, *Enterprise* reported, after the racing entry program had closed, that "the field of pacers and trotters . . . may never be equaled again in local history." Official race starter J.B. White (left) and racing secretary Lester W. Crounse (1893–1944) are prepared to oversee the scheduled three days of racing.

The late summer bounty of the farmlands surrounding Altamont is very evident in this photograph of produce displayed during the fair for judging. Several varieties of squash are shown among wax beans, peppers, potatoes, tomatoes, melons, pumpkins, and cabbage. Just as today, the poster at the rear left encourages people to eat fresh vegetables.

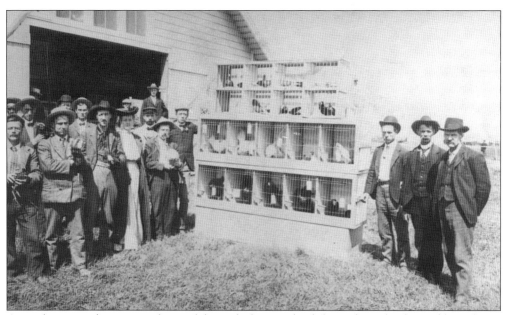

Agriculture was the primary focus of the early fairs, and exhibitors brought their rabbits, sheep, chickens, and cattle to be evaluated and judged. In 1905, these very serious poultry exhibitors, along with friends and family, presented an intimidating view for an approaching judge, particularly if he was prepared to make decisions regarding the show quality of the exhibited fowl.

There was always something at the fair to spark a child's curiosity. However, in August 1916, the Altamont Board of Health unanimously passed a resolution prohibiting all children less than 16 years of age from attending the fair, in an attempt to prevent the spread of infantile paralysis, or polio. The fair board protested but agreed. Subsequently, attendance was the smallest since the fair started 23 years prior.

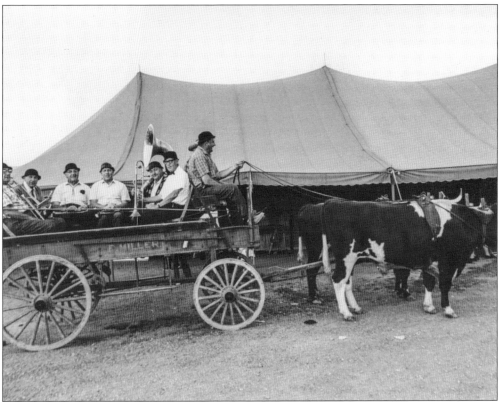

Entertainment came in many forms over the years that the fair has been in operation. In 1897, the fair's name was changed from Altamont Fair to the Albany County Agricultural Exposition. In 1921, Schenectady County partnered with Albany County, forming the first bi-county fair. In 1945, Greene County joined with Albany and Schenectady to form a tri-county fair, as it remains today.

The tri-county Altamont Fair provided an opportunity for many local vendors to display their products. After World War II, the desire for new products and a change in the focus of the economy to consumerism brought a new perspective to the fair. While agricultural exhibits were still a large part of the fair's drawing power, new product displays tried to be as eye-catching as possible. Millard H. Severson was the local vendor for Philgas; as such, he tried to ensure that all of his best products were on display. Here, Carmen Hilton, wife of George B. Hilton, hosts the Philgas "kitchen of the future" exhibit around 1946. She was a Gold Star Mother. Her son Boyd C. Hilton died in 1943 at age 20 in a naval attack during World War II. He was Altamont's first World War II casualty.

# About the Organization

The mission of the Village of Altamont Archives and Museum is to collect and preserve important historical documents, photographs, and ephemera relating to the cultural, educational, and municipal history of the Village of Altamont (incorporated in 1890), its citizens, and founders. A series of changing curated exhibitions are held in the Hallway Exhibition Gallery, supported by generous donors and grants from the Roger W. Keenholts Fund, Altamont Community Tradition (ACT), and private donors.

Additional history about the collections, images, and research from past exhibitions and the research work by volunteers can be found on our website and *Facebook* page: https://www.facebook.com/VillageOfAltamontArchivesAndMuseum.

# Discover Thousands of Local History Books
## Featuring Millions of Vintage Images

Arcadia Publishing, the leading local history publisher in the United States, is committed to making history accessible and meaningful through publishing books that celebrate and preserve the heritage of America's people and places.

Find more books like this at
**www.arcadiapublishing.com**

Search for your hometown history, your old stomping grounds, and even your favorite sports team.

Consistent with our mission to preserve history on a local level, this book was printed in South Carolina on American-made paper and manufactured entirely in the United States. Products carrying the accredited Forest Stewardship Council (FSC) label are printed on 100 percent FSC-certified paper.